Doorways
and
Openings

A Collection of
Photographic Images
to Cut Out and Use
in Personal Art

Catherine Anderson

www.creativepilgrimage.com

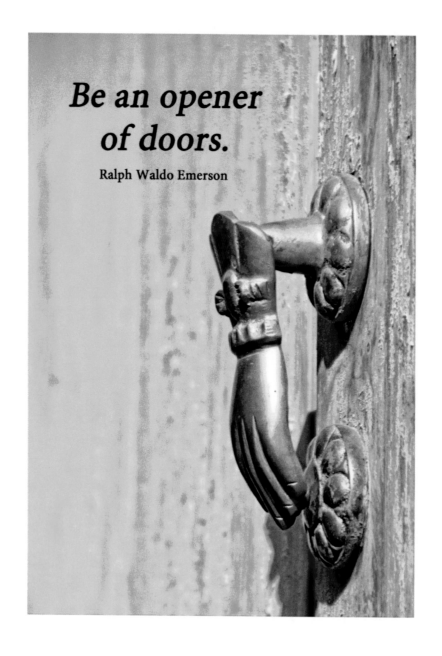

Be an opener
of doors.

Ralph Waldo Emerson

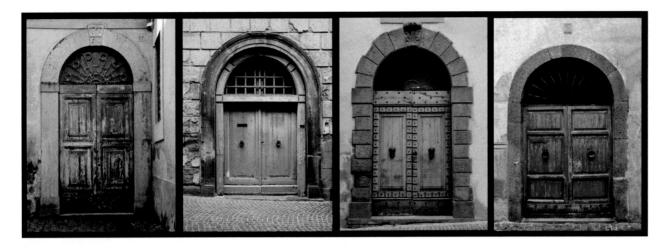

Dear Fellow Artist,

I have always had a fascination with doors and a love of their rich symbolism. Doors open up the imagination - consider the many people who might have crossed the thresholds of these doors throughout the years and what secrets might have been hidden behind them.

I photograph doors in every country I visit, and see them as a way of getting to know the culture. From ornate to simple, from colorful to plain, each door has a unique character. The collection of doors in this book comes mostly from India, France, Italy and Mexico, with a few from Africa, Ireland and America.

I created this collection of images so participants in my SoulCollage® workshops and mixed media classes would have doors to use in their projects and art journals. Most of the doors have been sized to fit a standard 5x8 inch SoulCollage® card. You can find out more about the SoulCollage® process at www.soulcollage.com.

To get the most out of this book, pull off the cover and tear out the pages! Use the images in collage art, art journals, craft projects or on SoulCollage® cards. I encourage you to share these creations freely on your website, blog or social media sites.

The majority of pages in this book are created with the same door on the front and back of the page so that when you "open" the door by cutting it with a craft knife or scissors, the back of the door matches the front of the door. Towards the end of the book are doors with textured images on the back of the page, and you can decide whether to "open" the door or keep it closed.

Images of doors also make great writing prompts, and I hope the selection of quotations at the end of the book relating to doors, portals and openings inspire you to look beyond the closed door.

May your creative spirit enter these doorways with joy and a sense of adventure,
Catherine

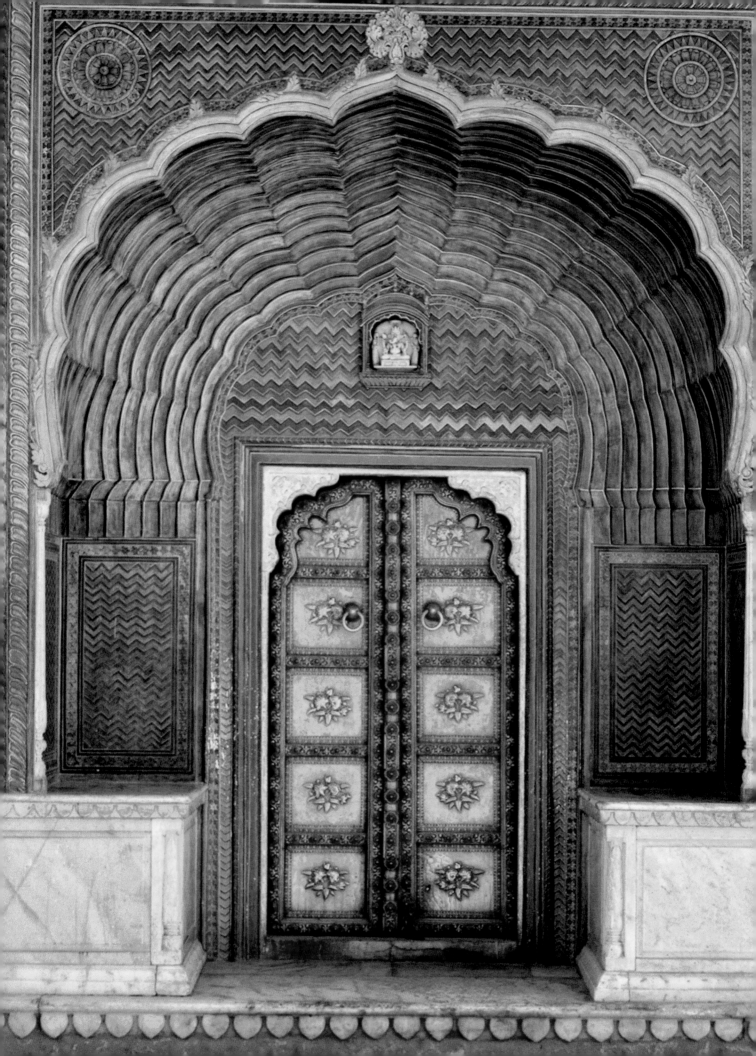

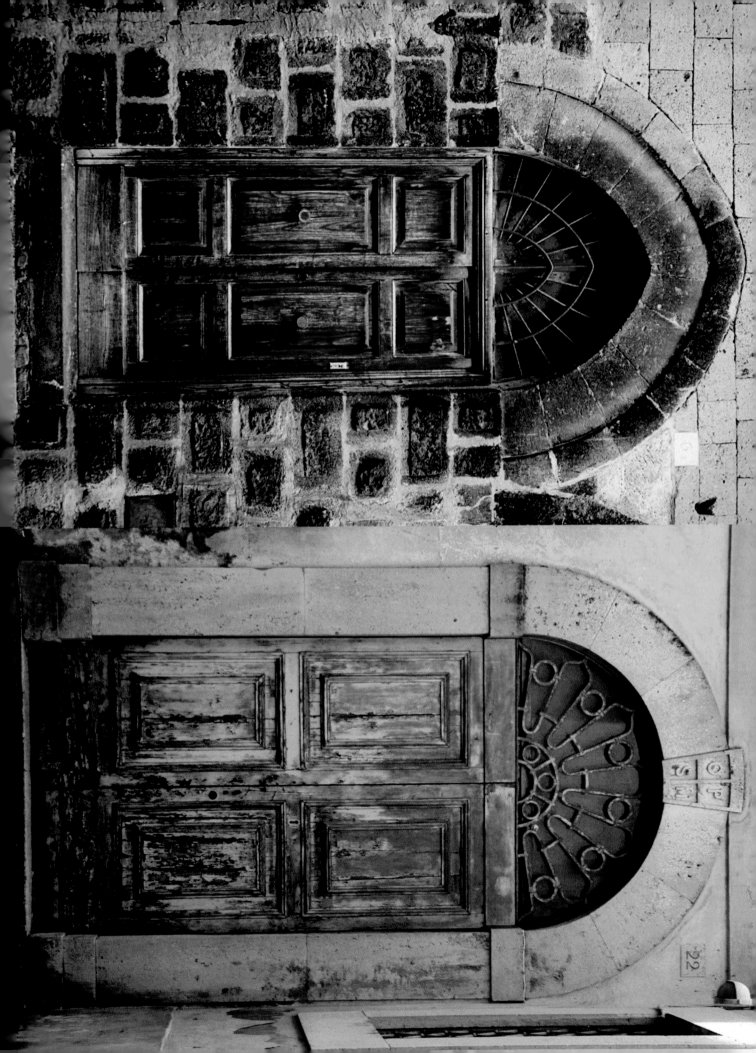

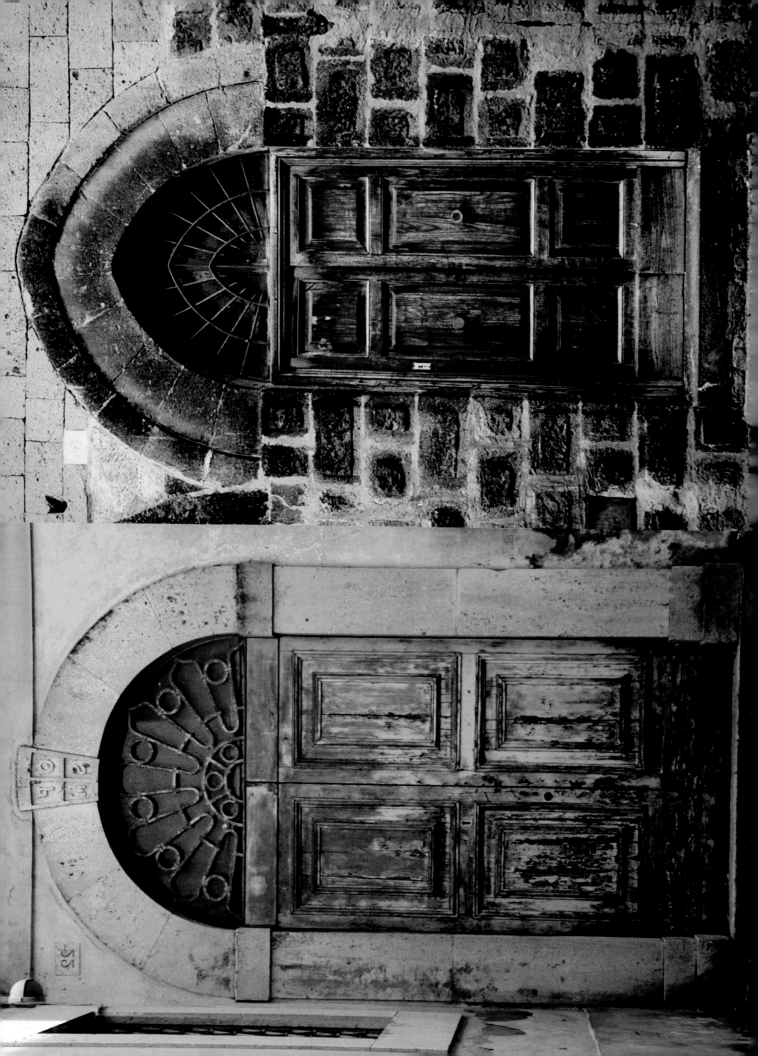

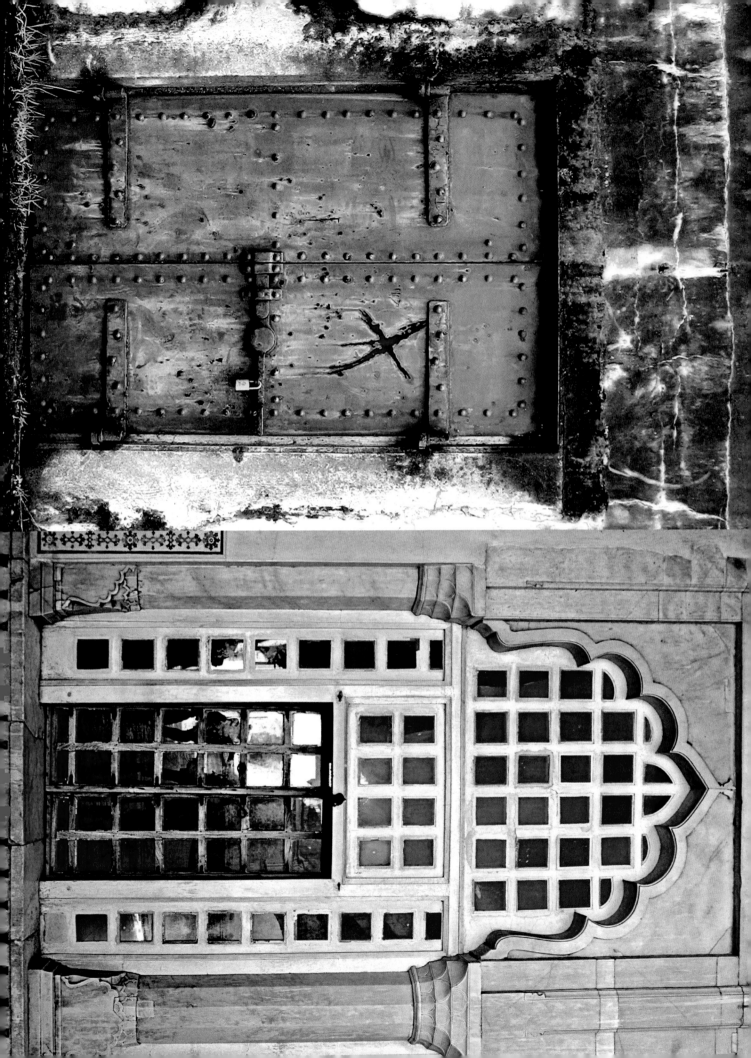

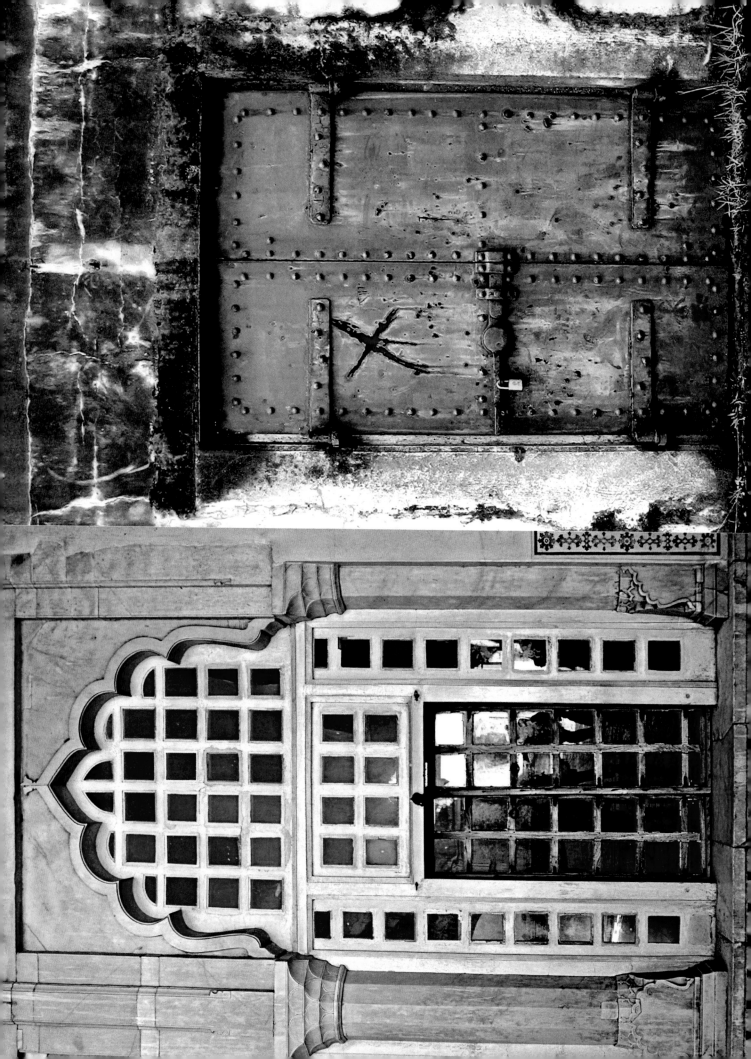

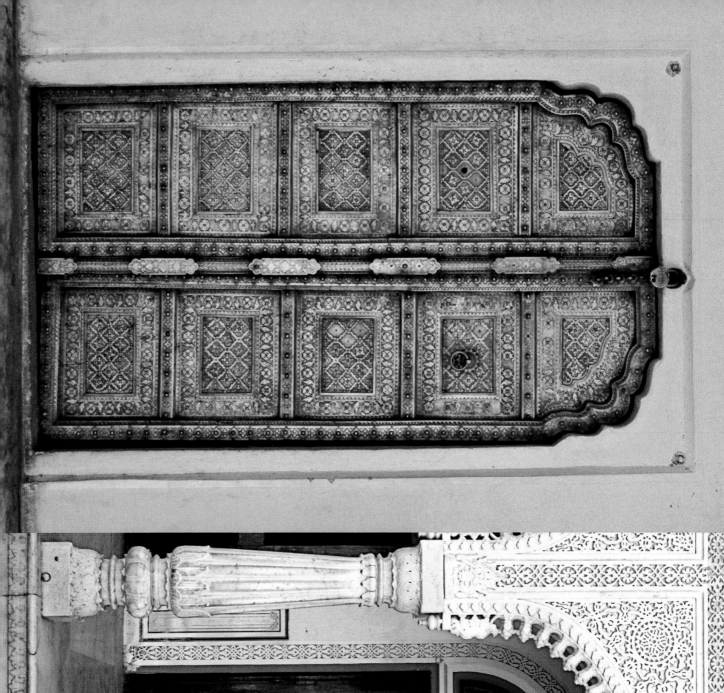
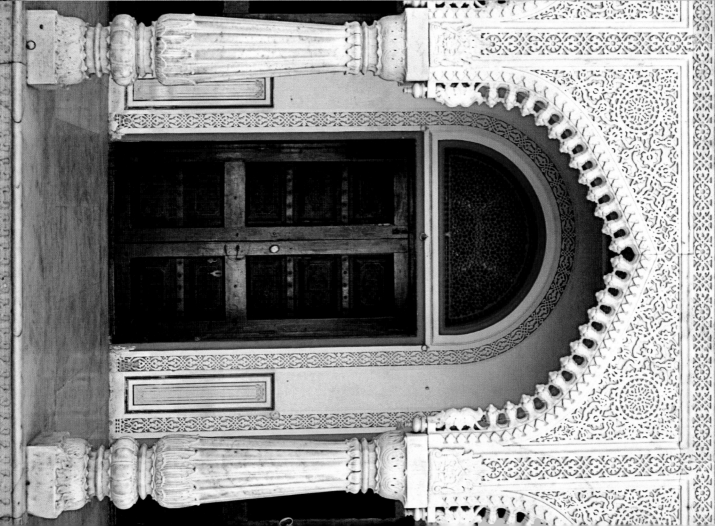

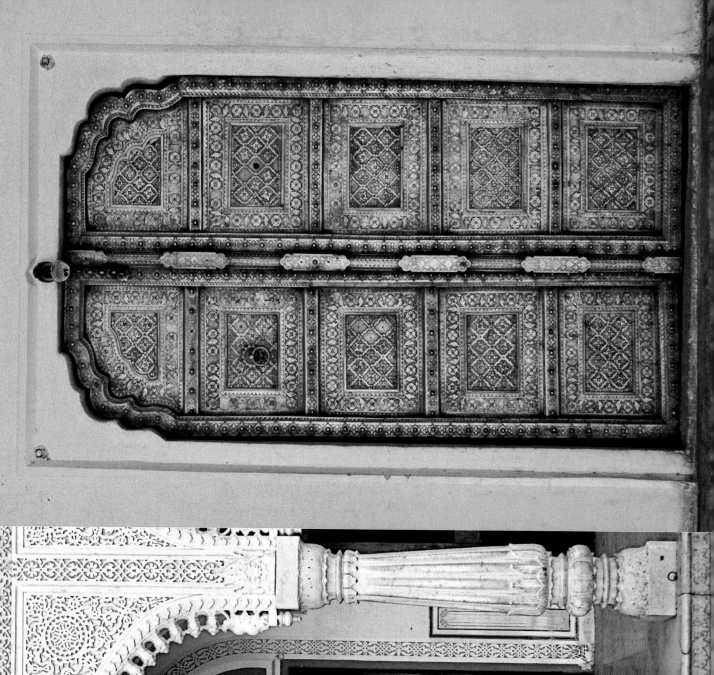

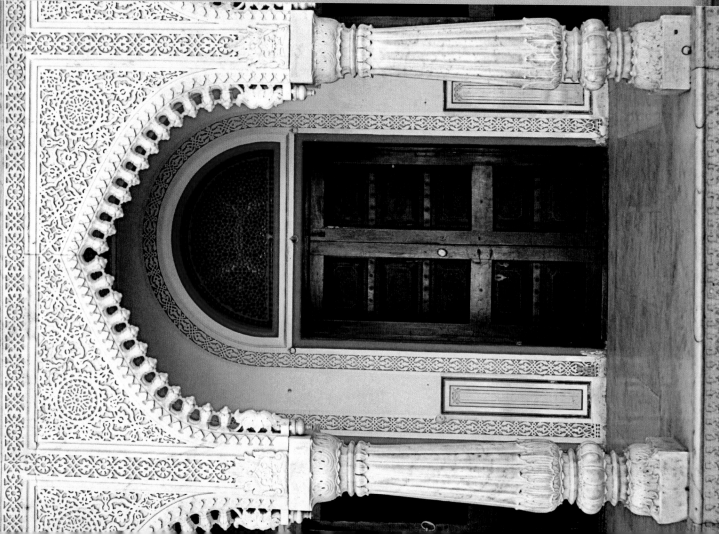

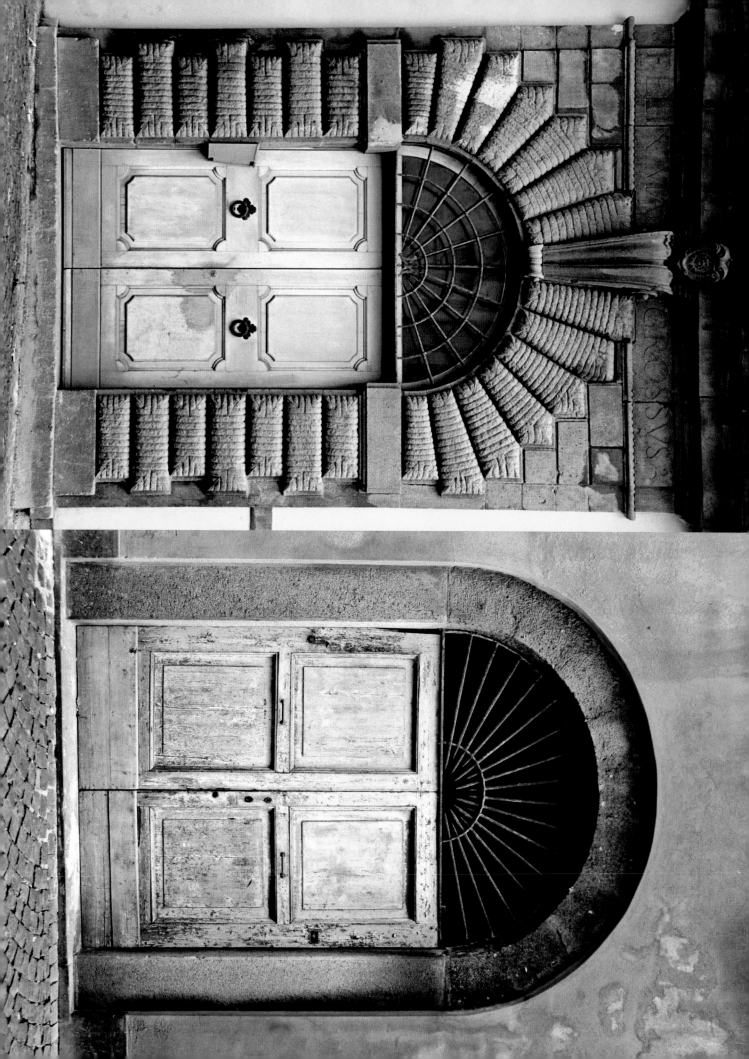

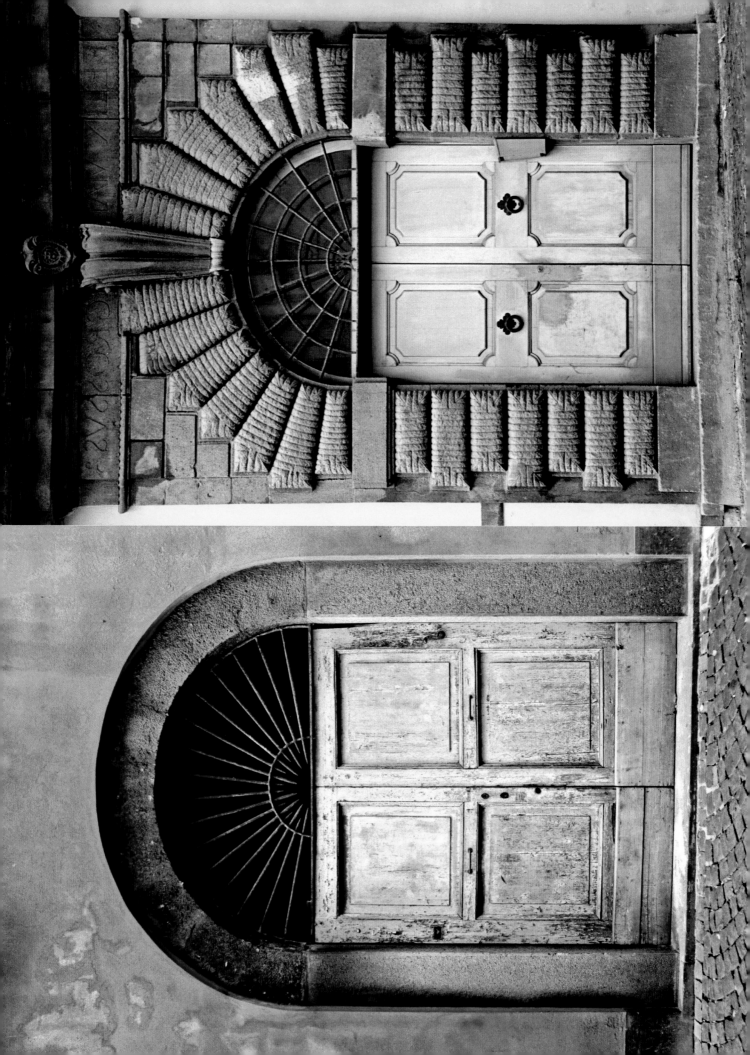

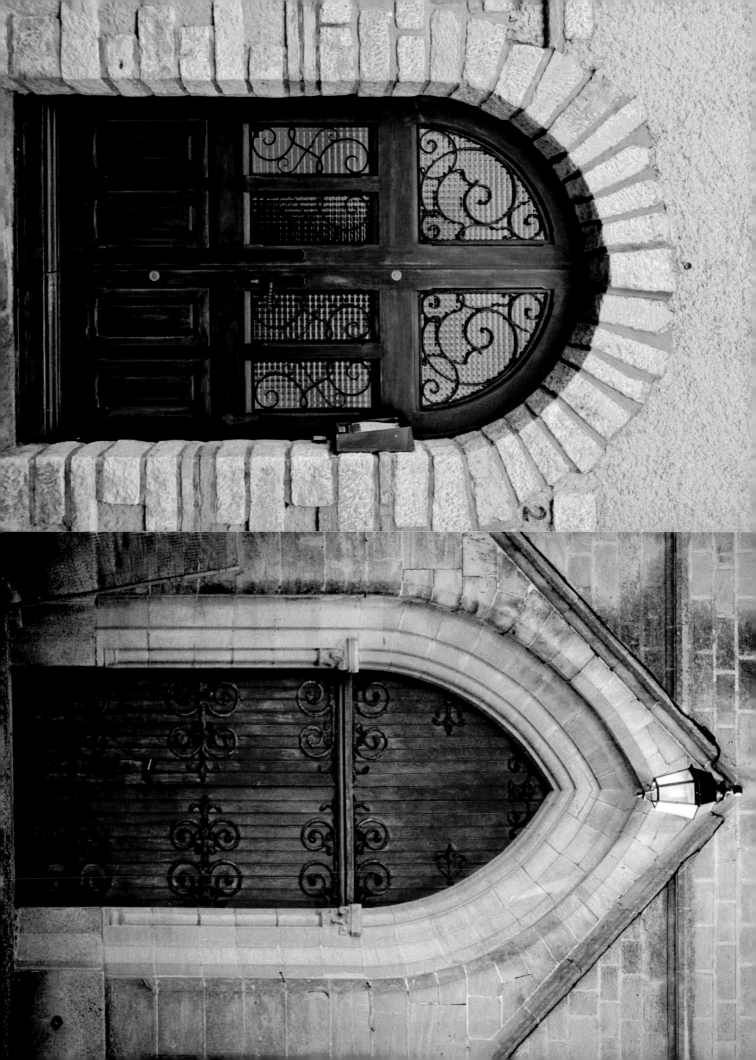

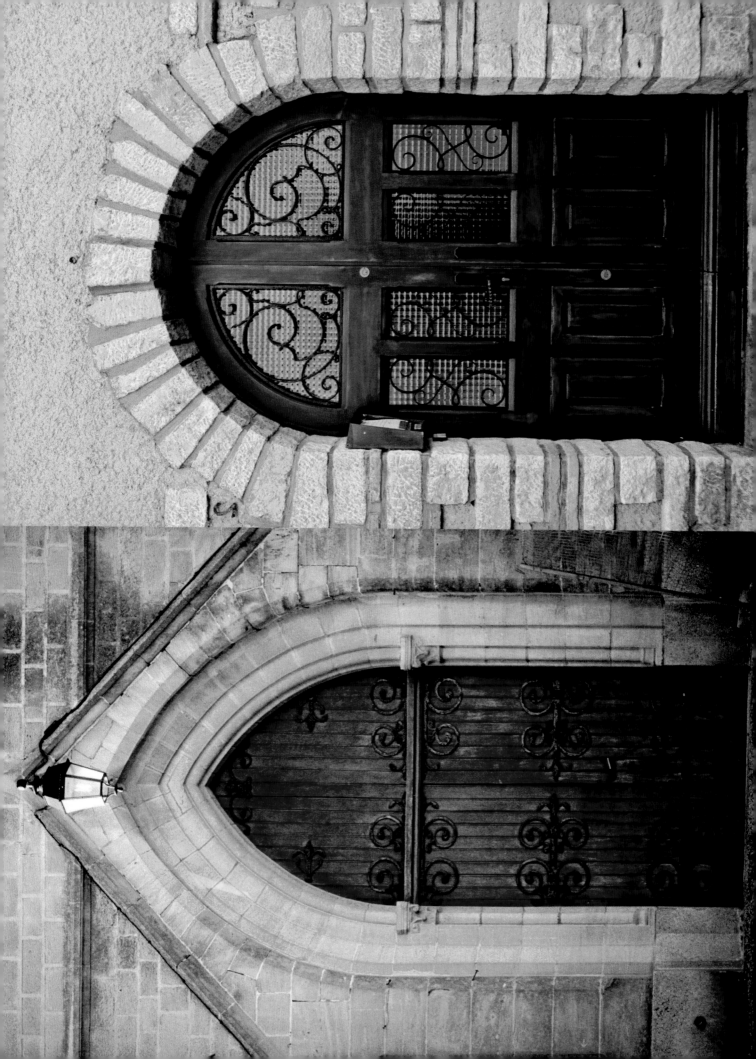

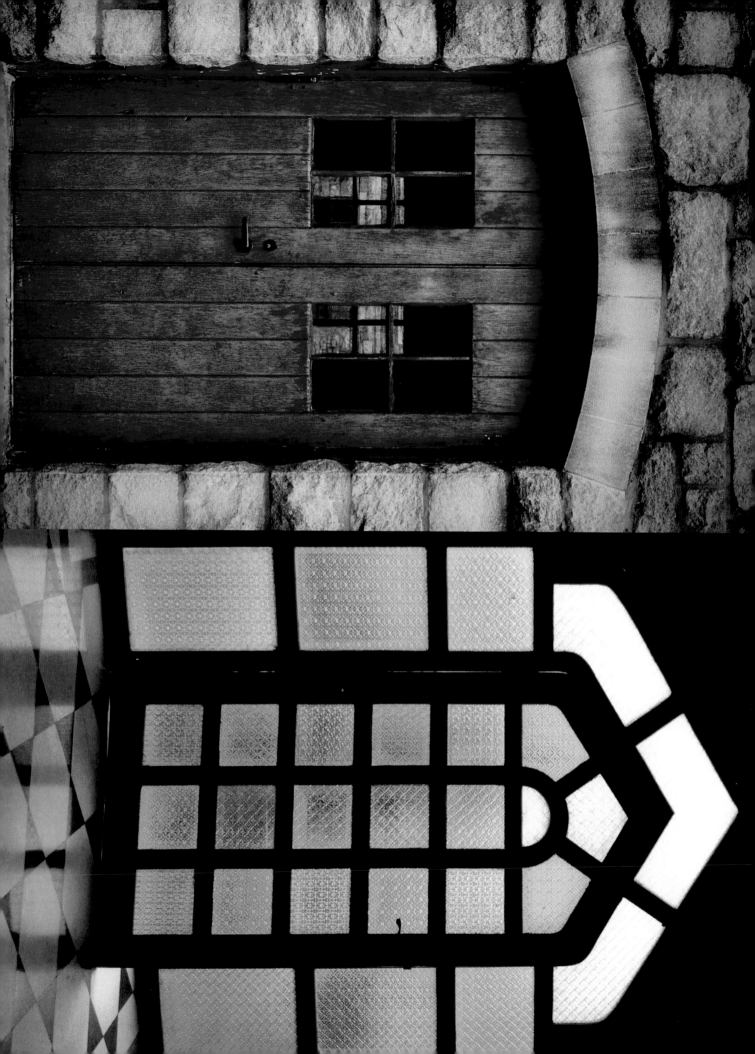

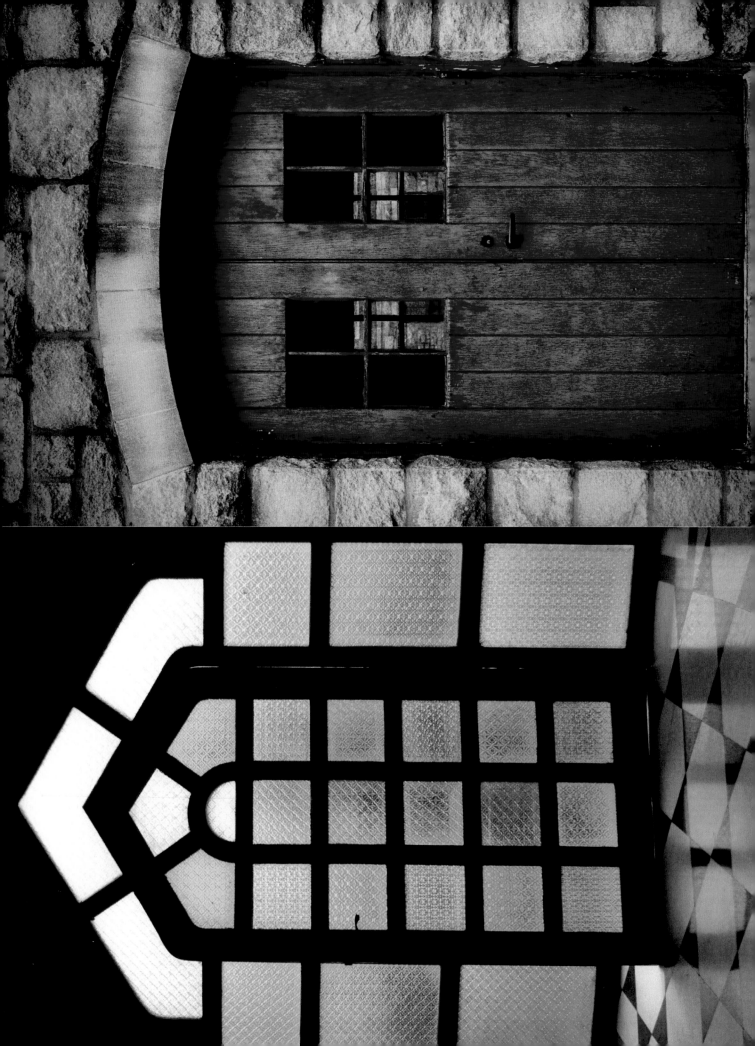

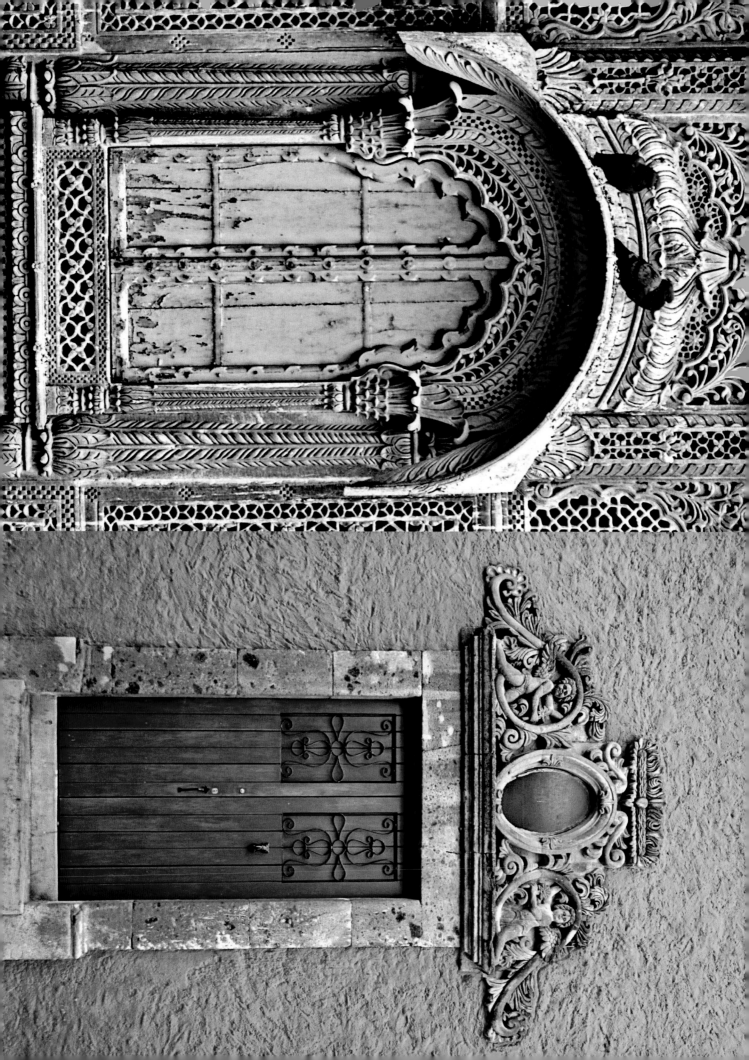

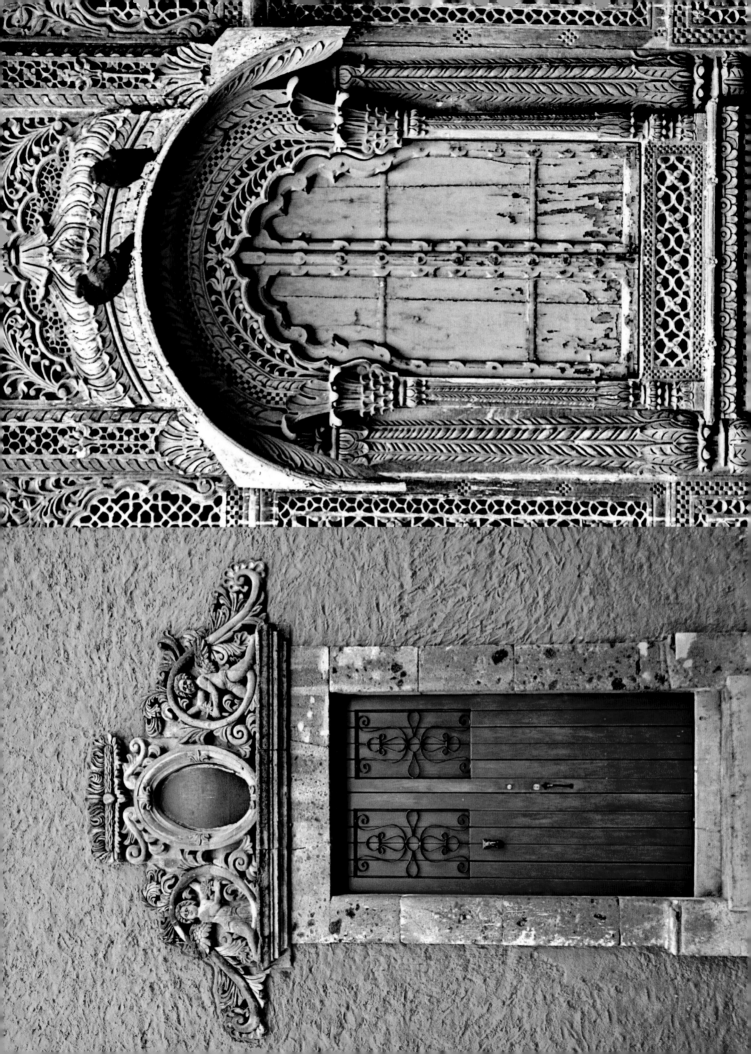

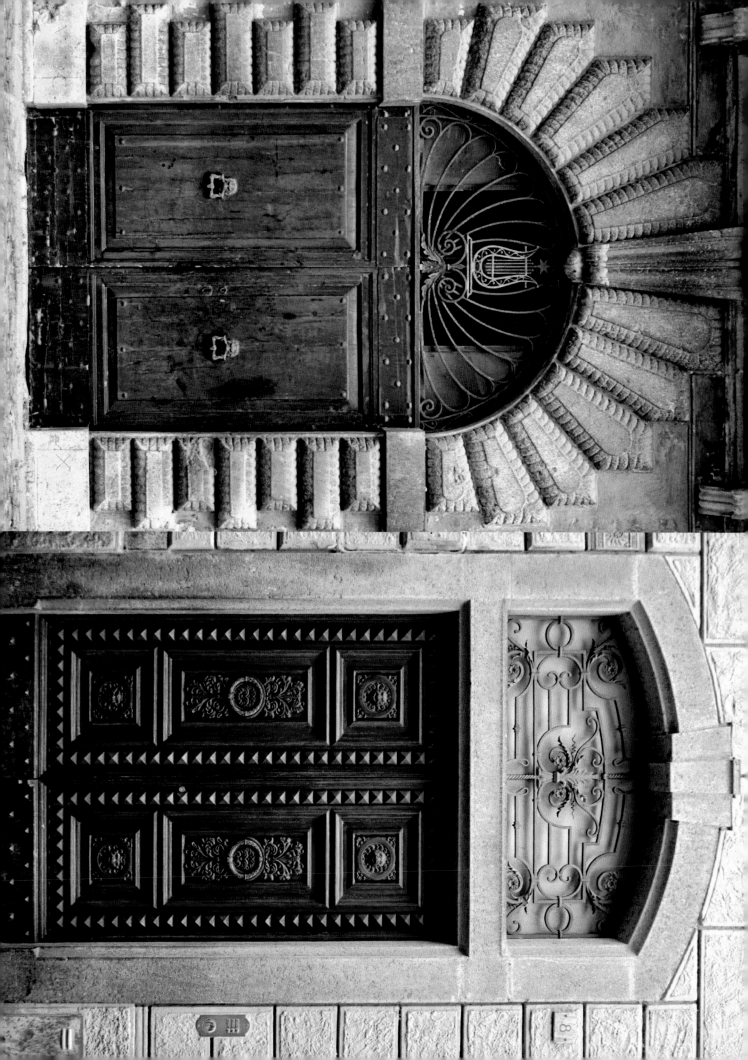

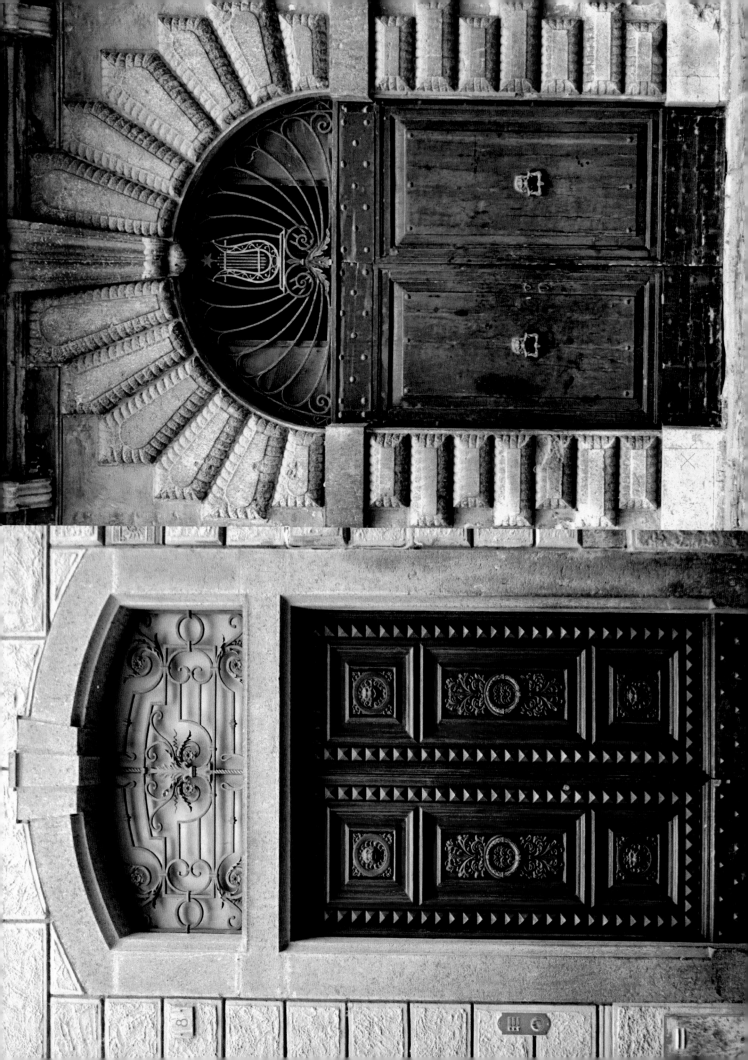

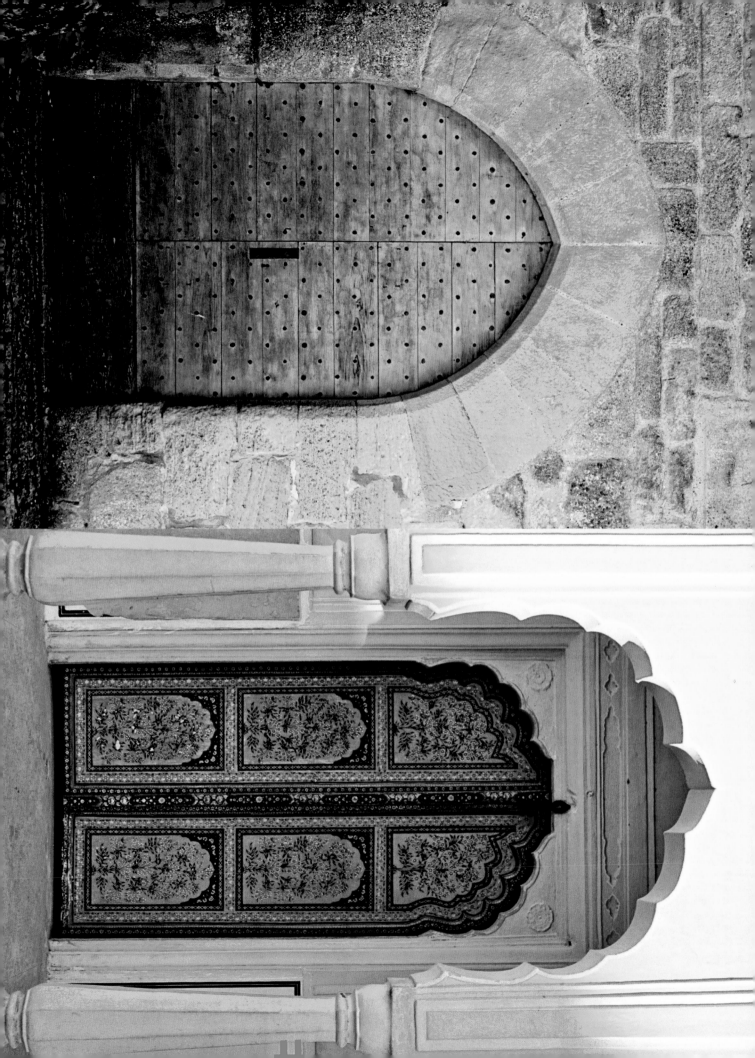

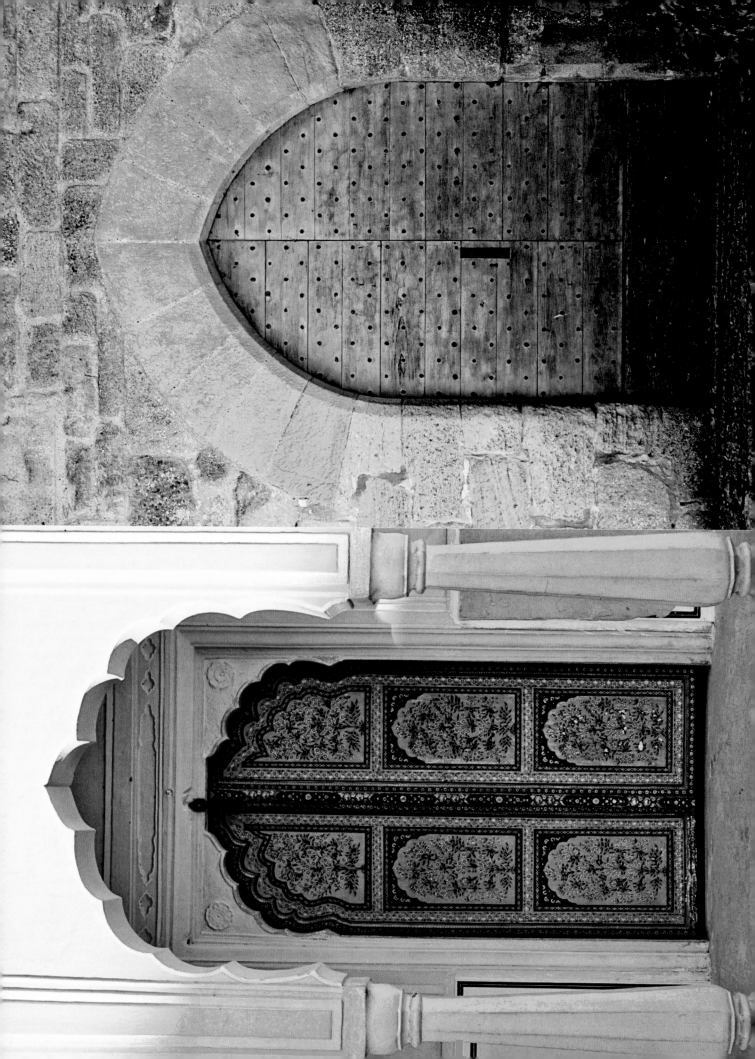

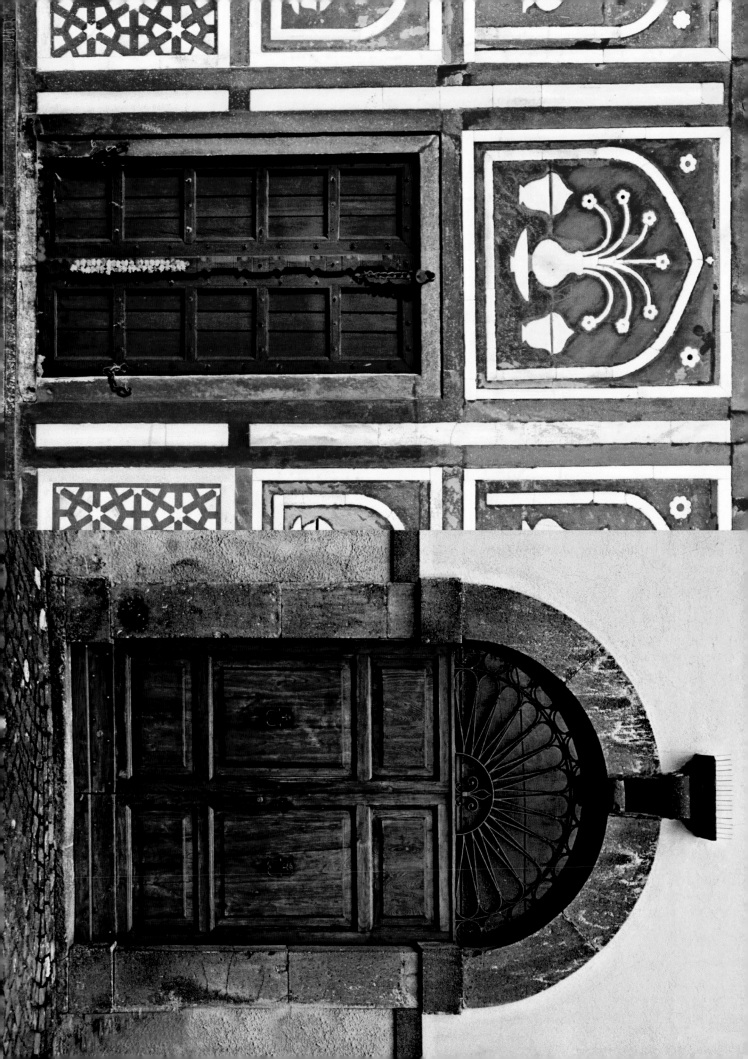

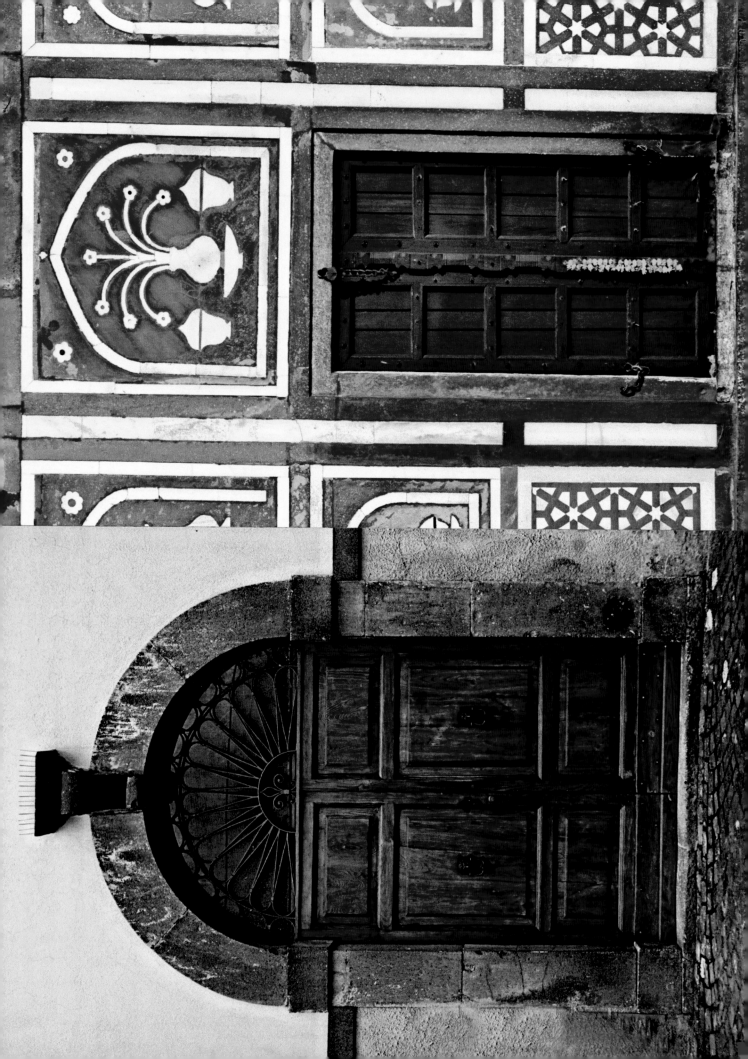

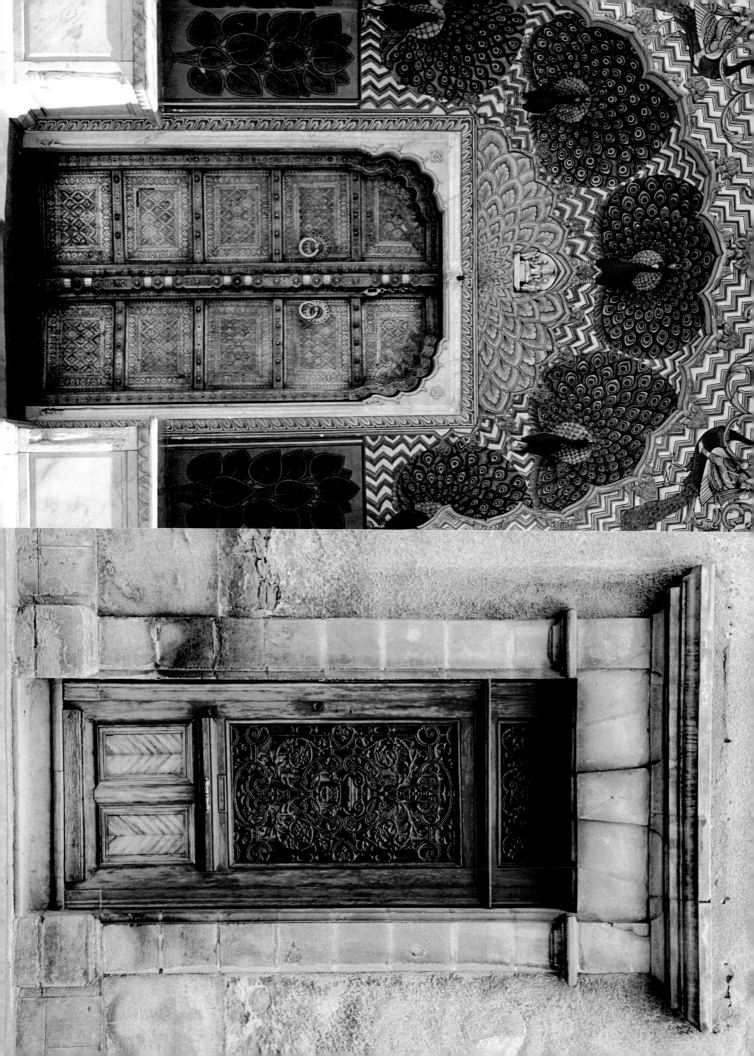

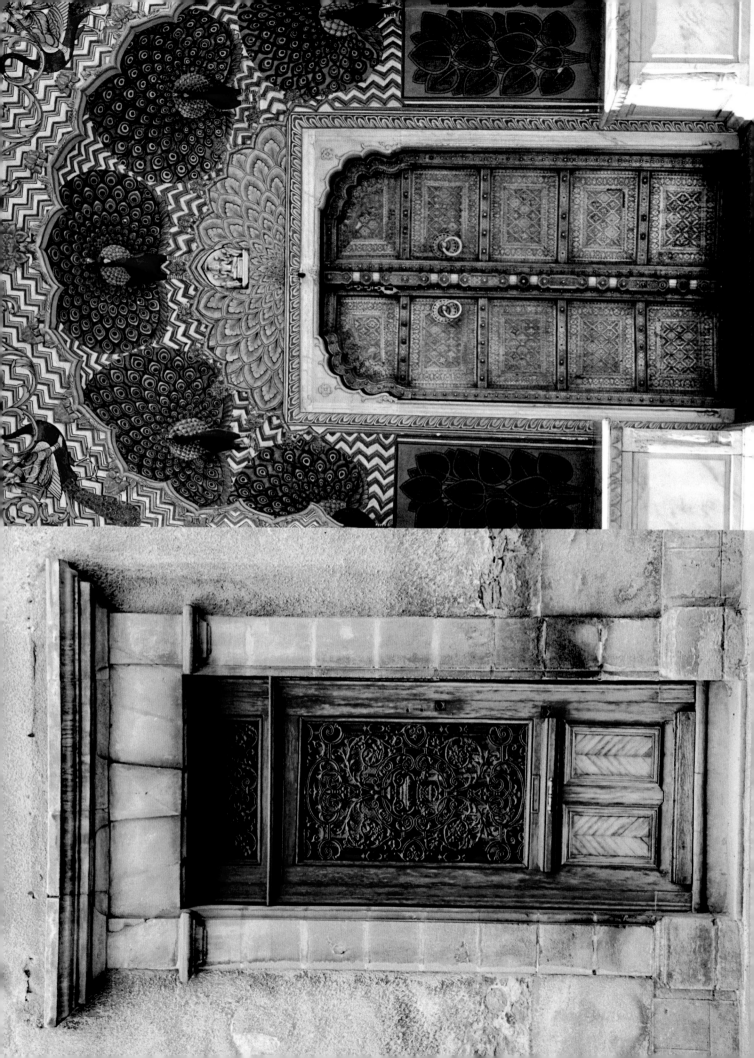

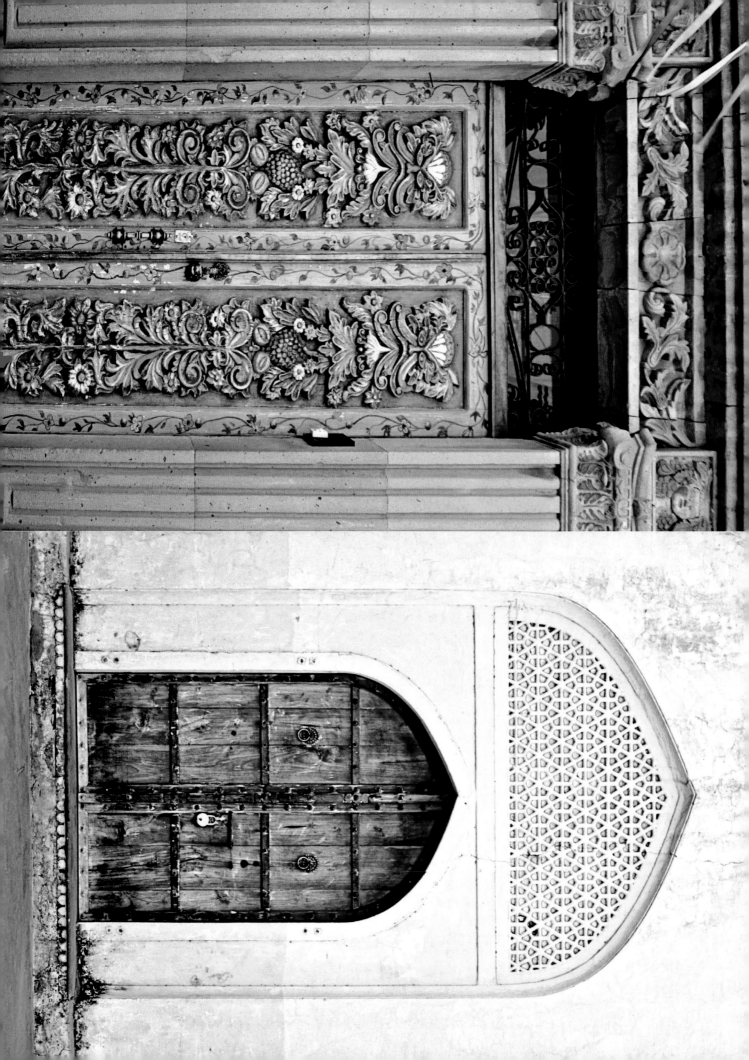

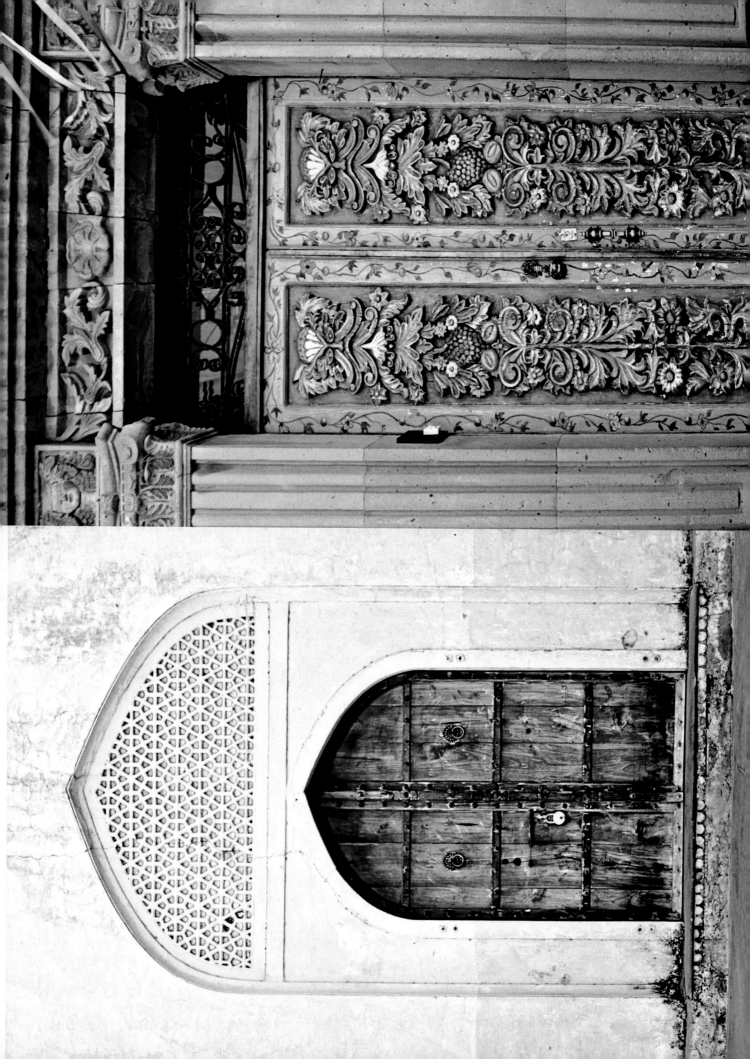

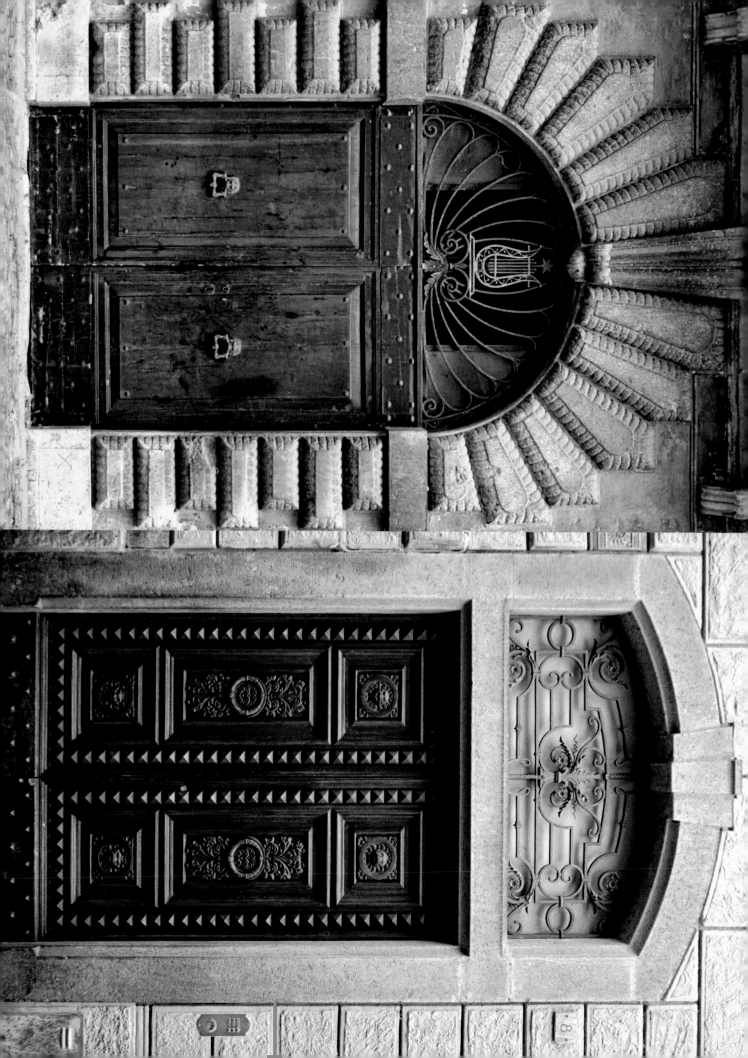

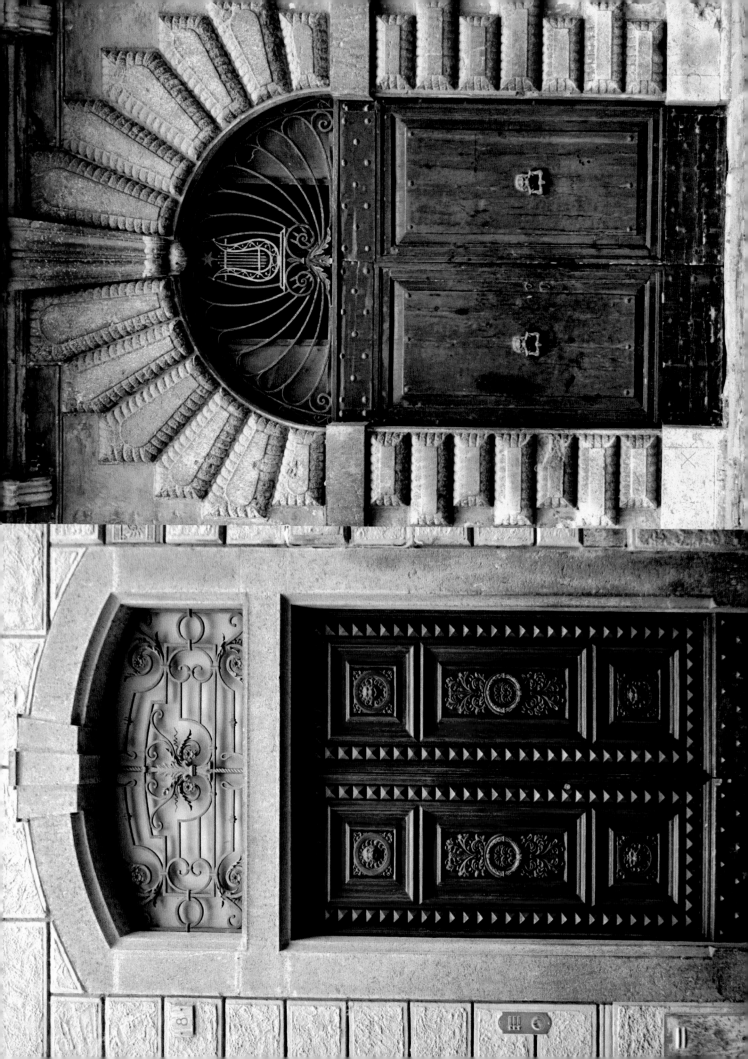

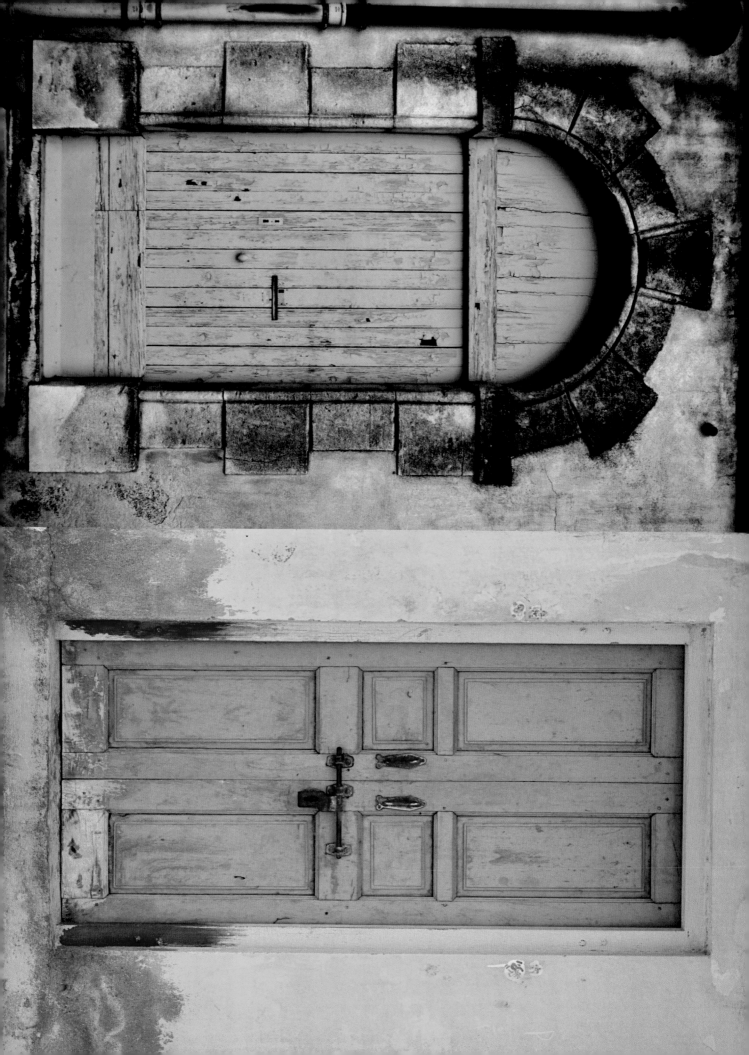

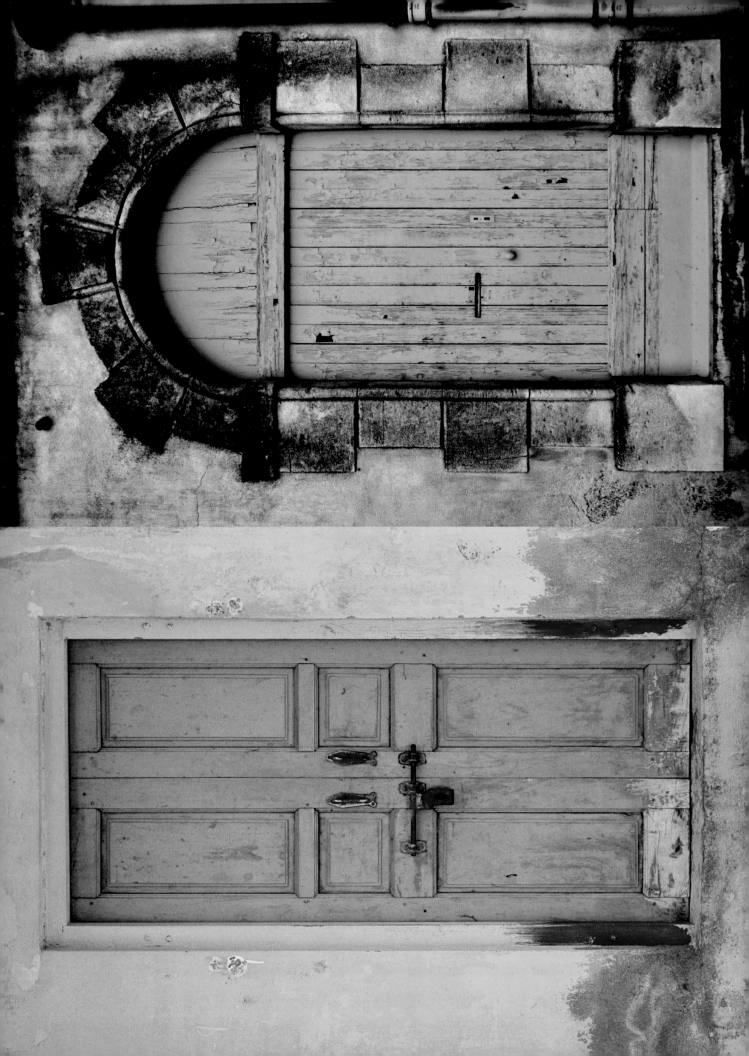

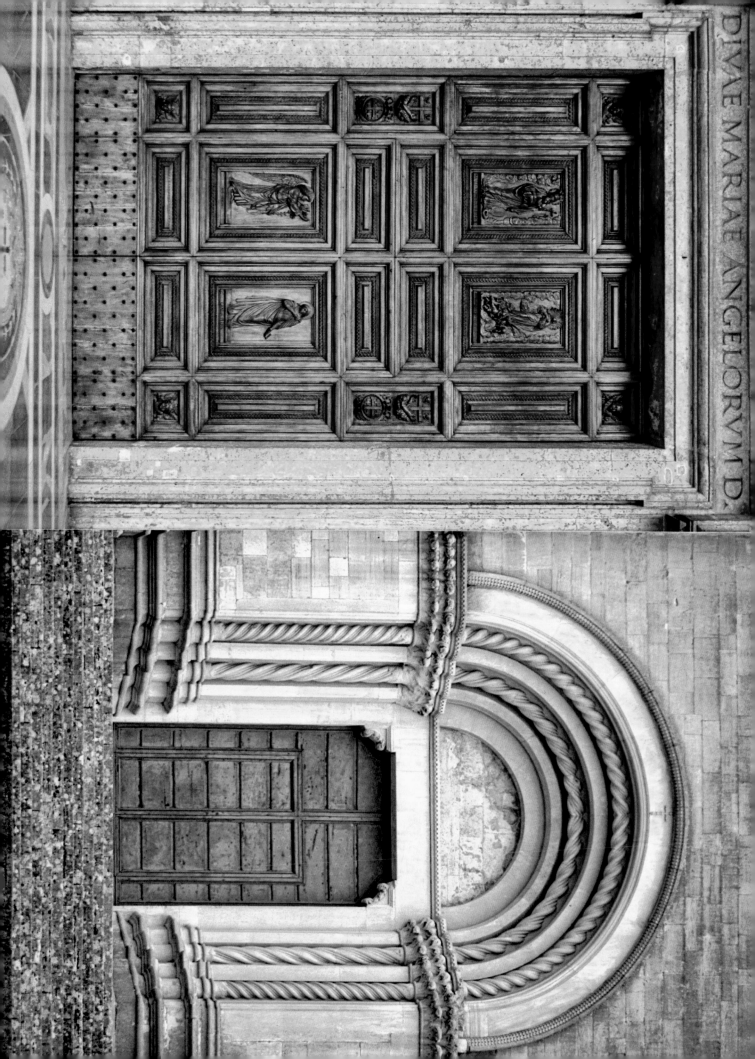

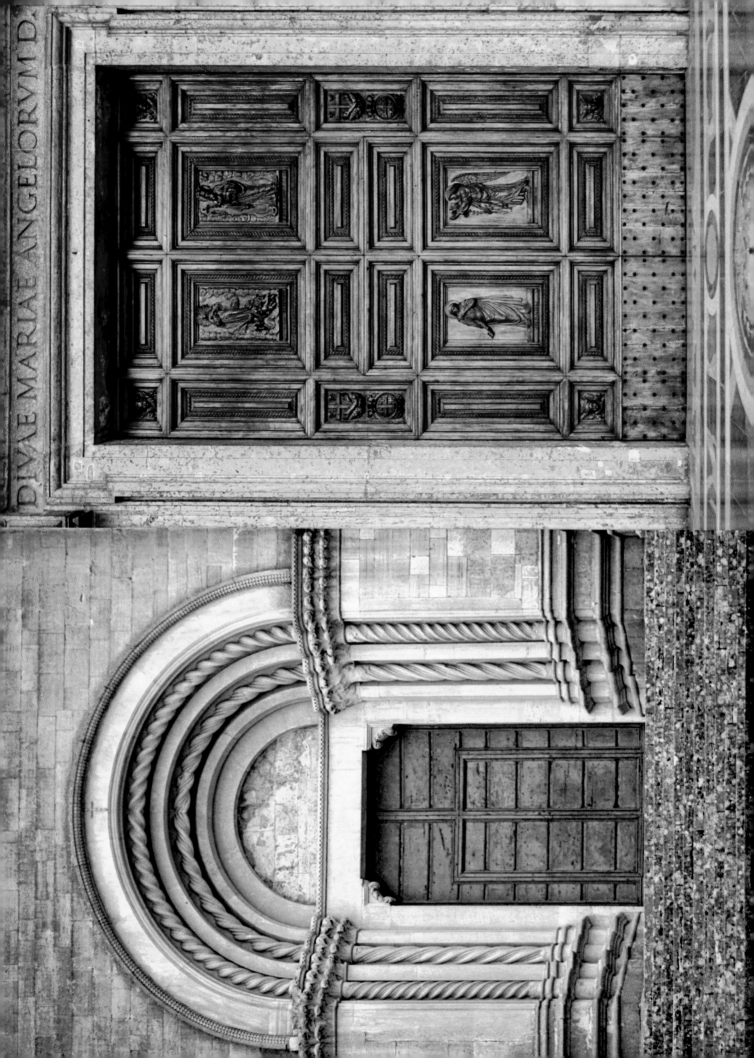

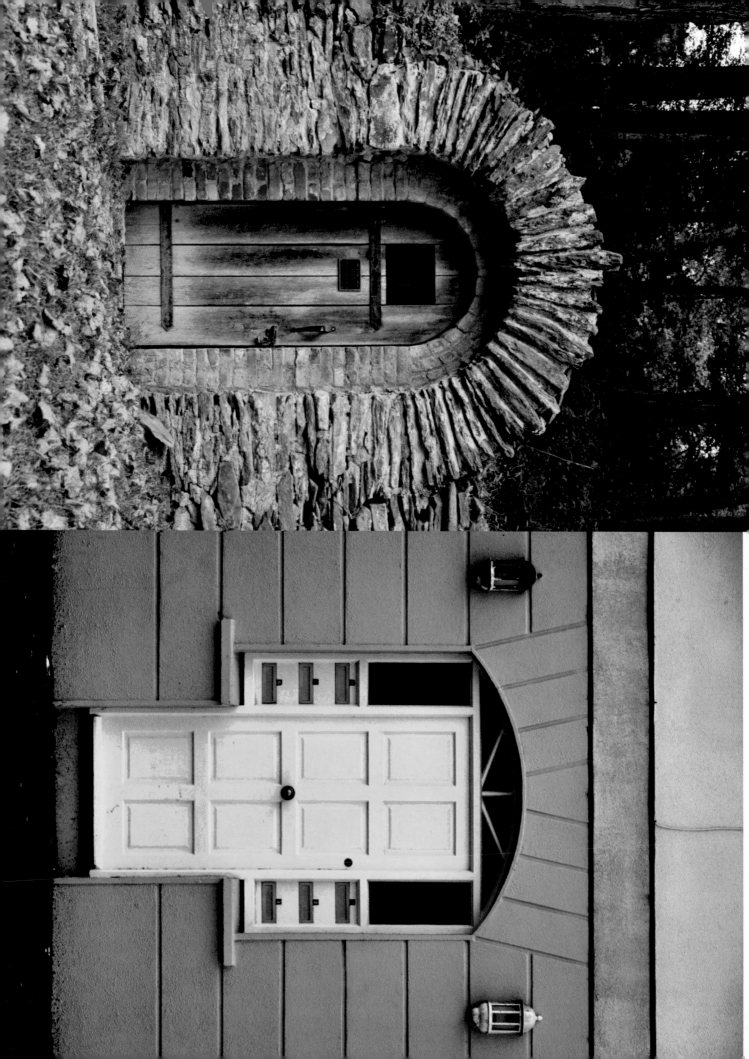

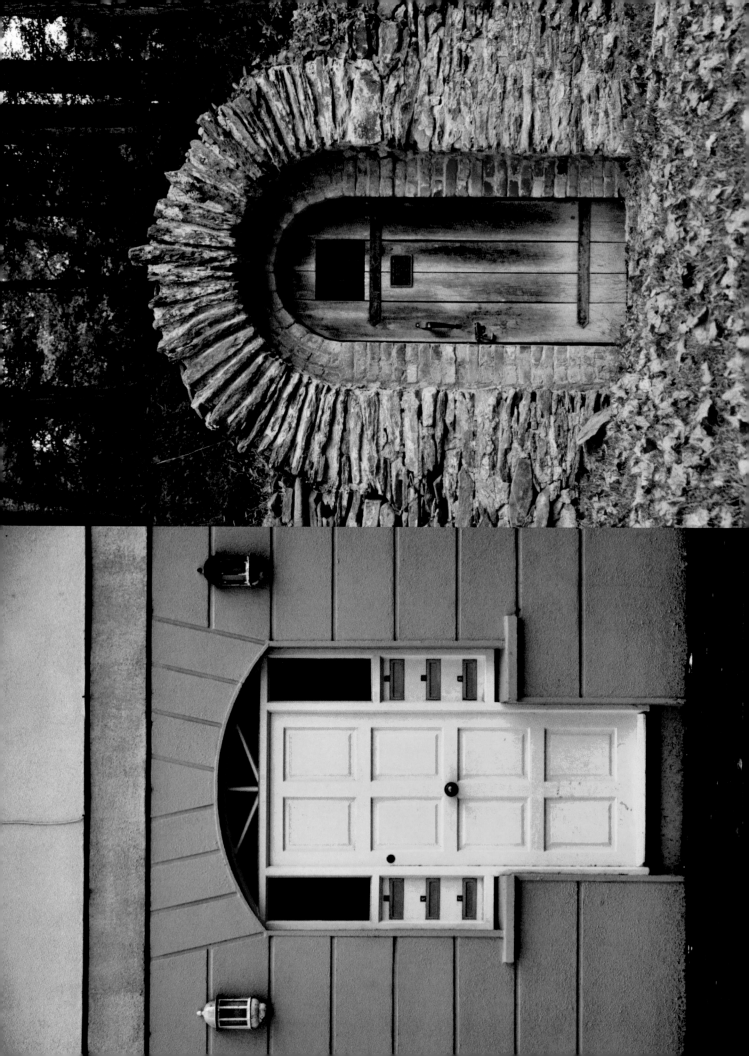

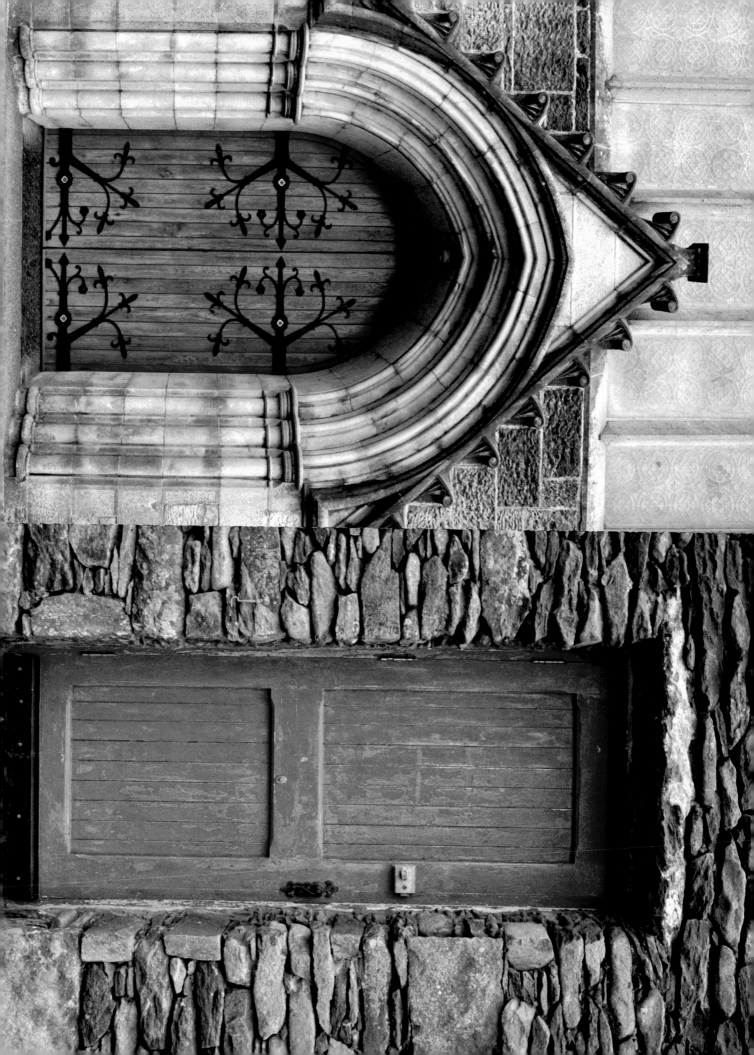

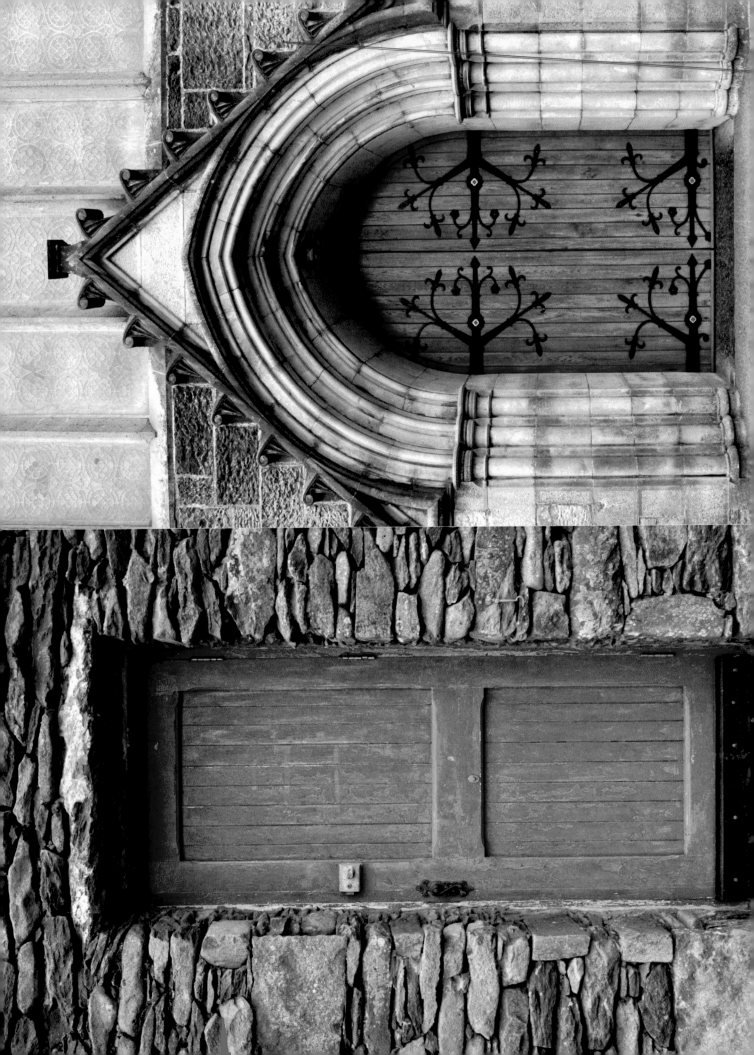

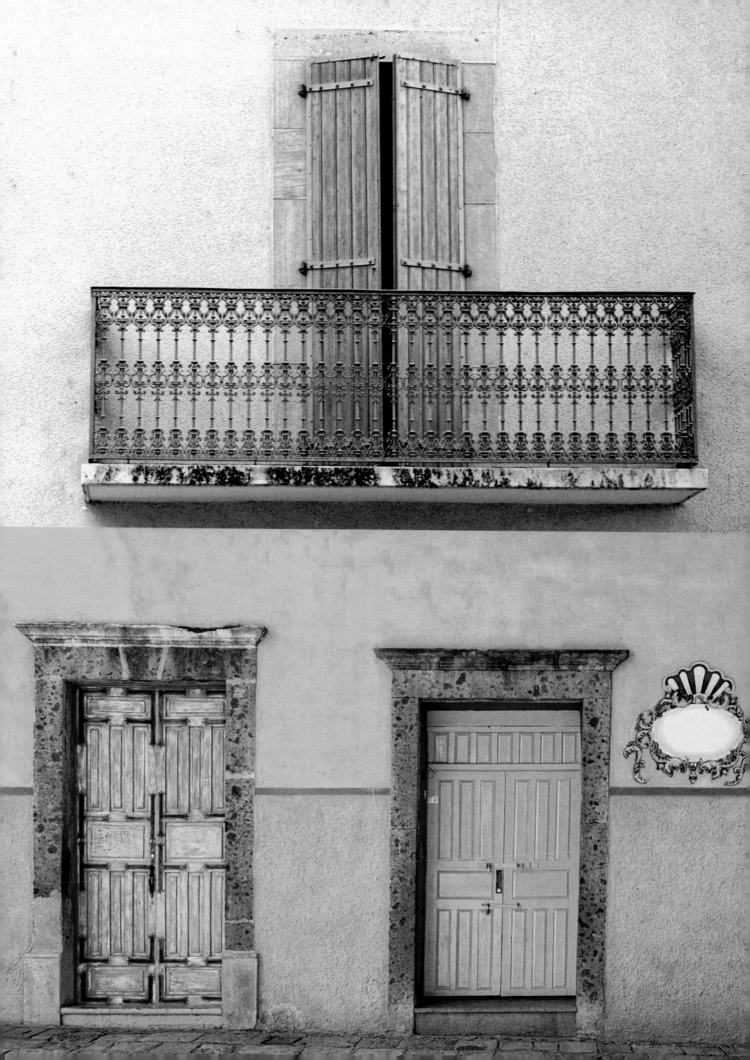

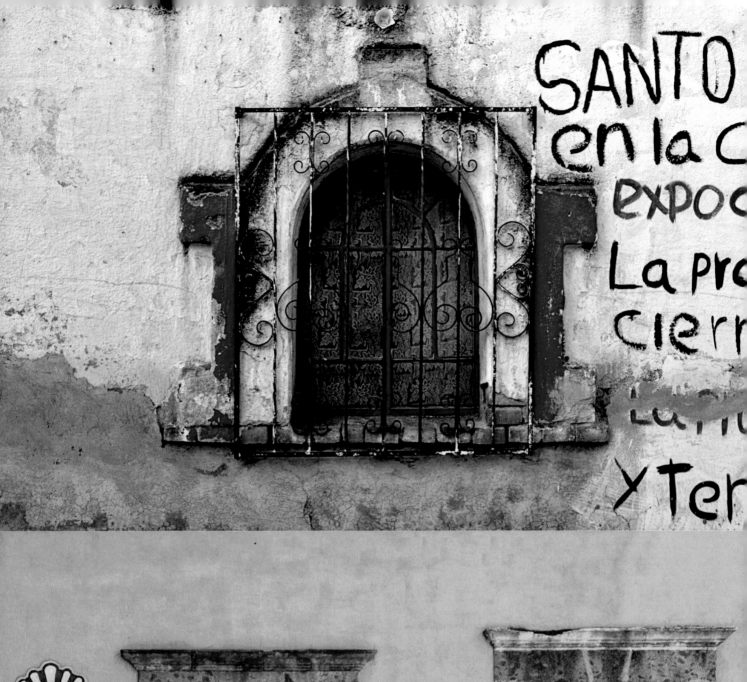

SANTO
en la C
expoc
La Pro
cierr
La
yTe

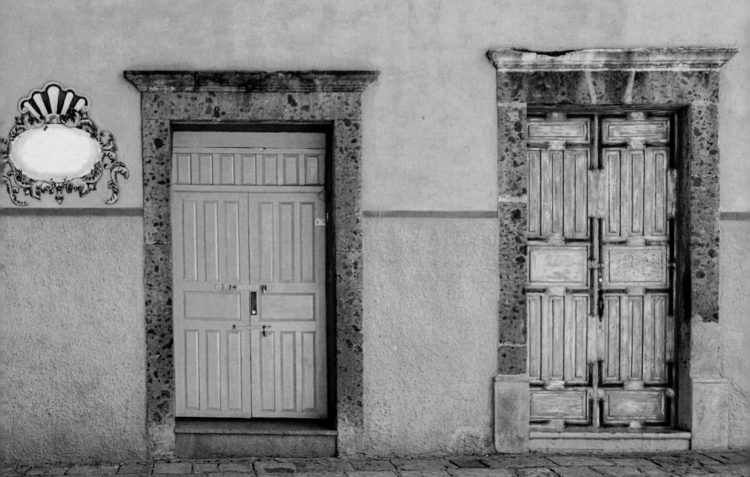

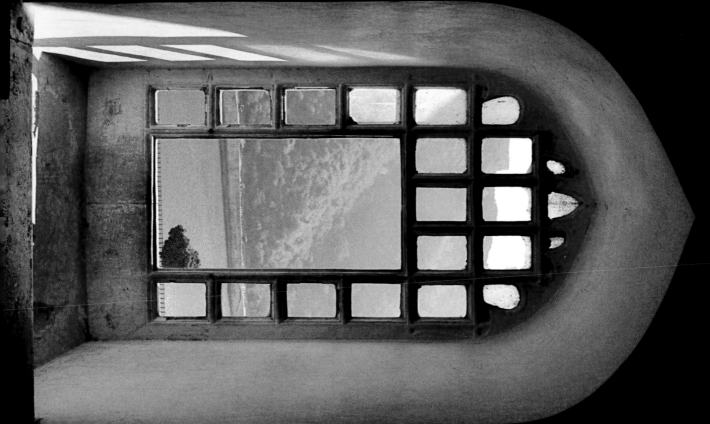

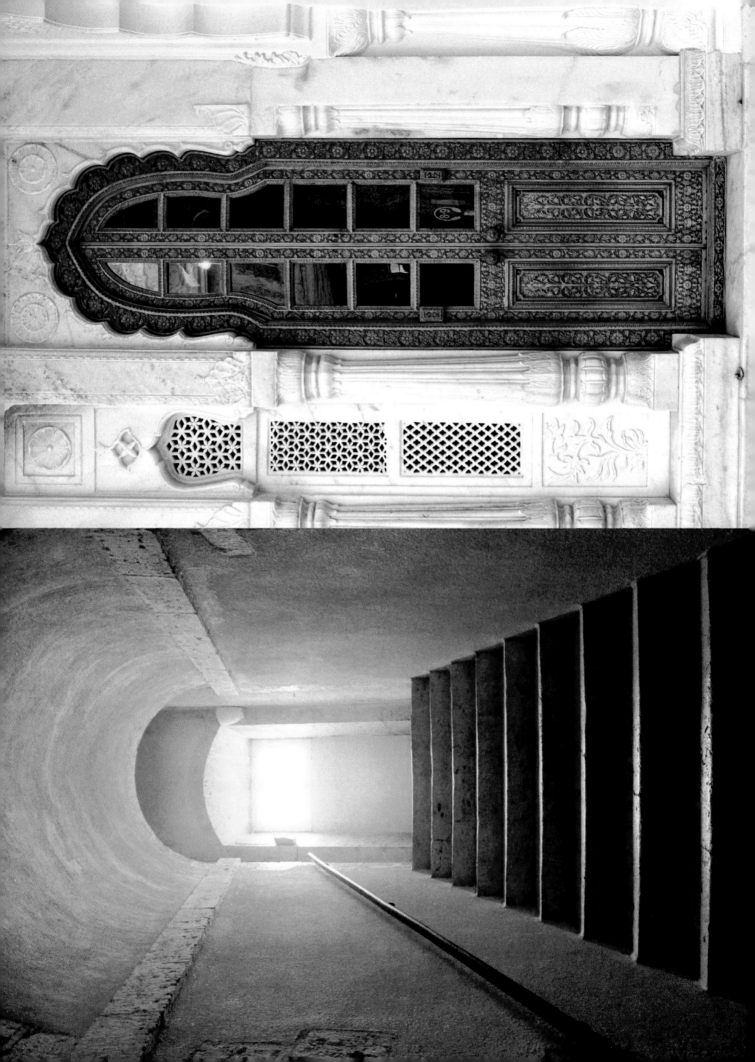

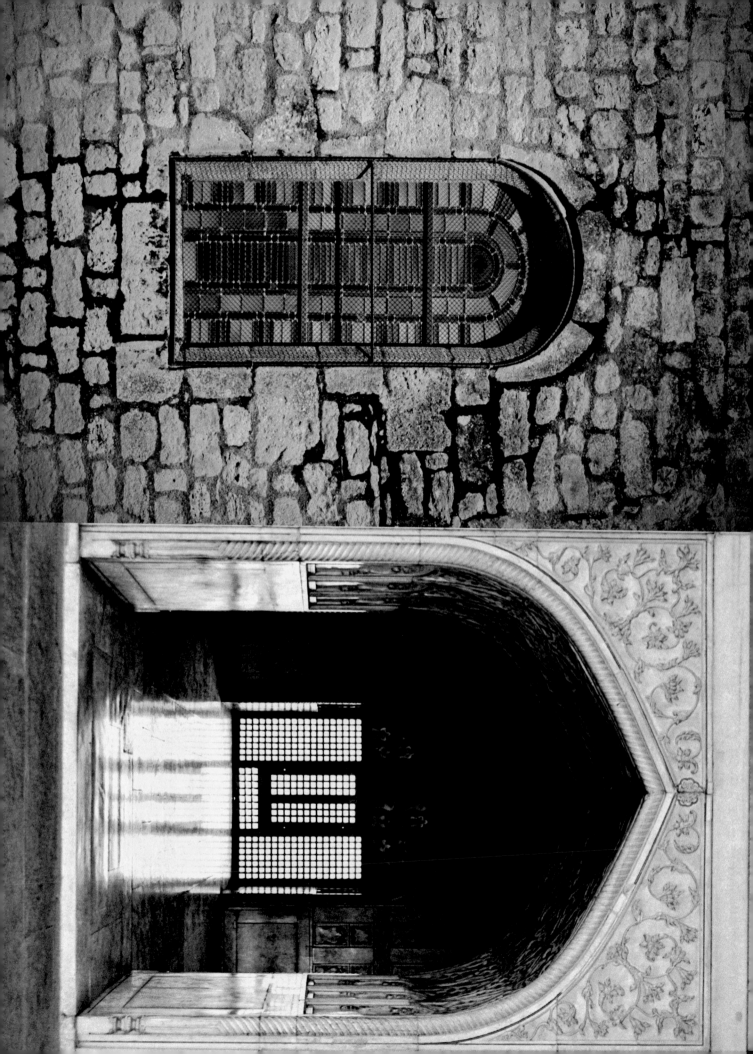

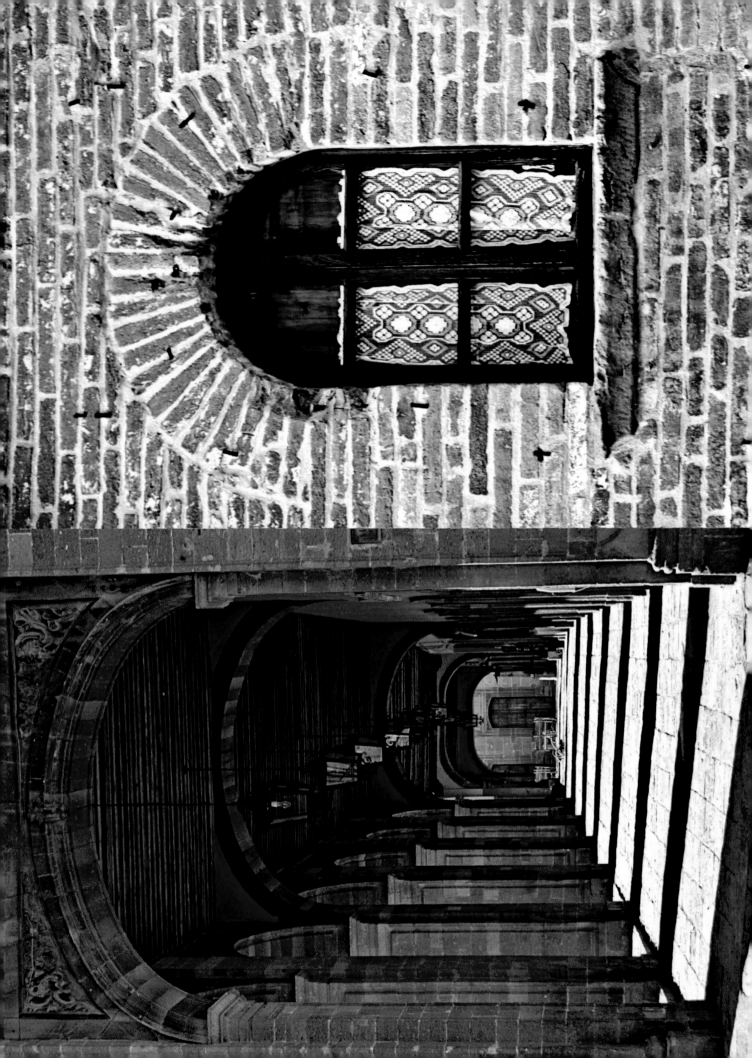

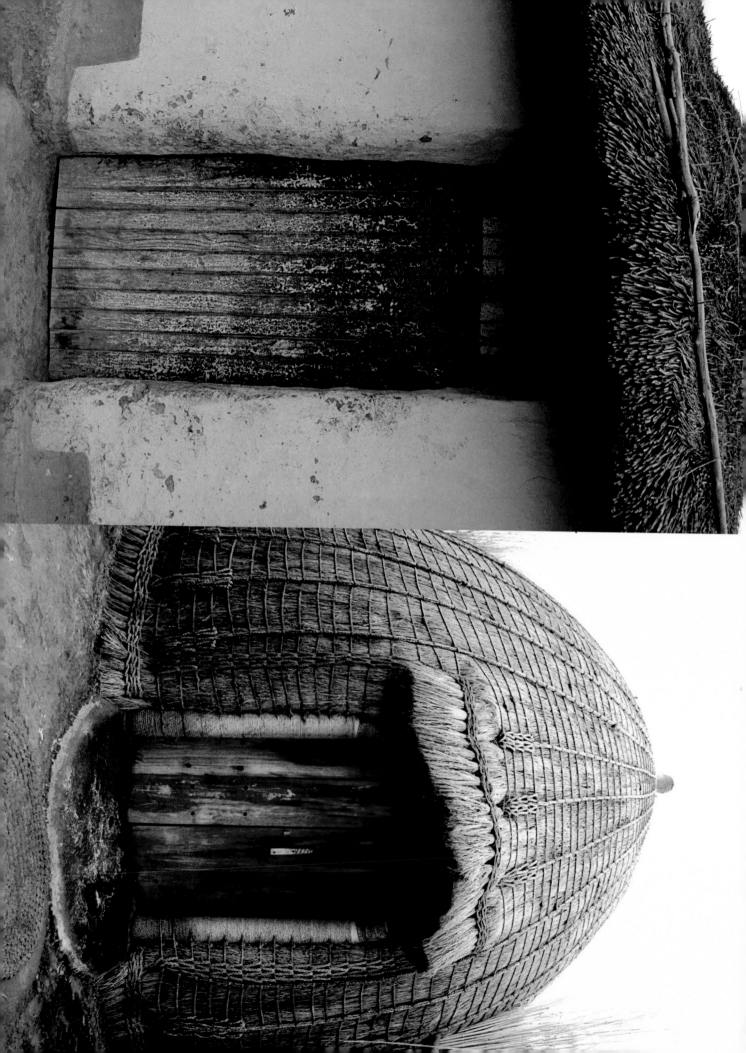

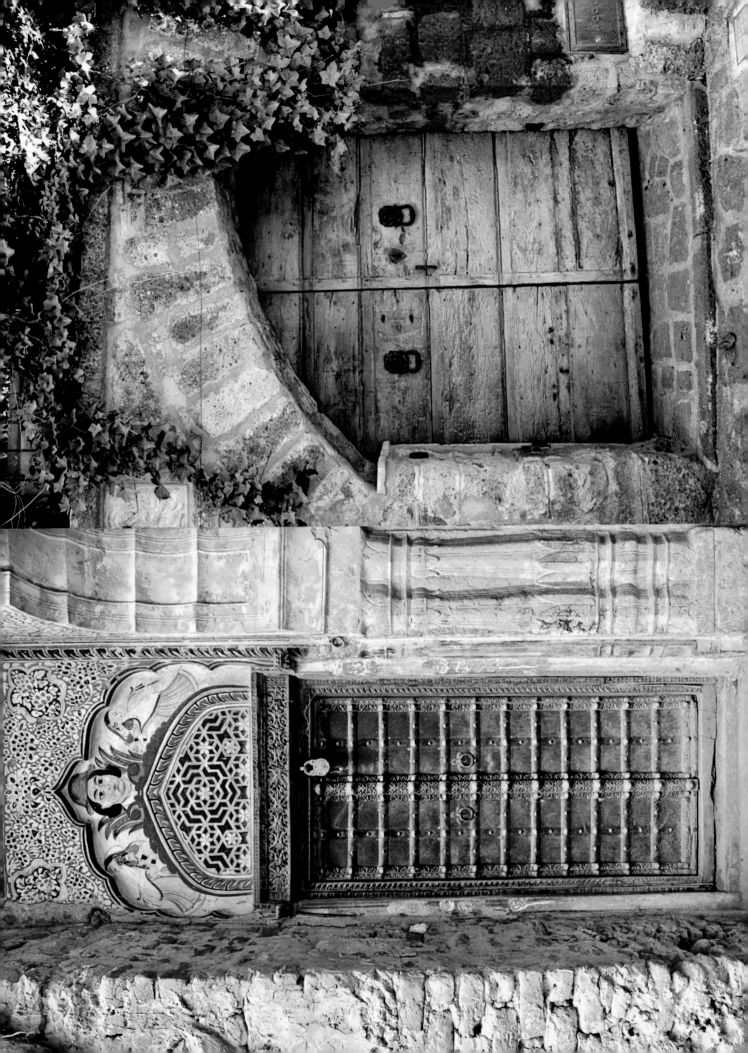

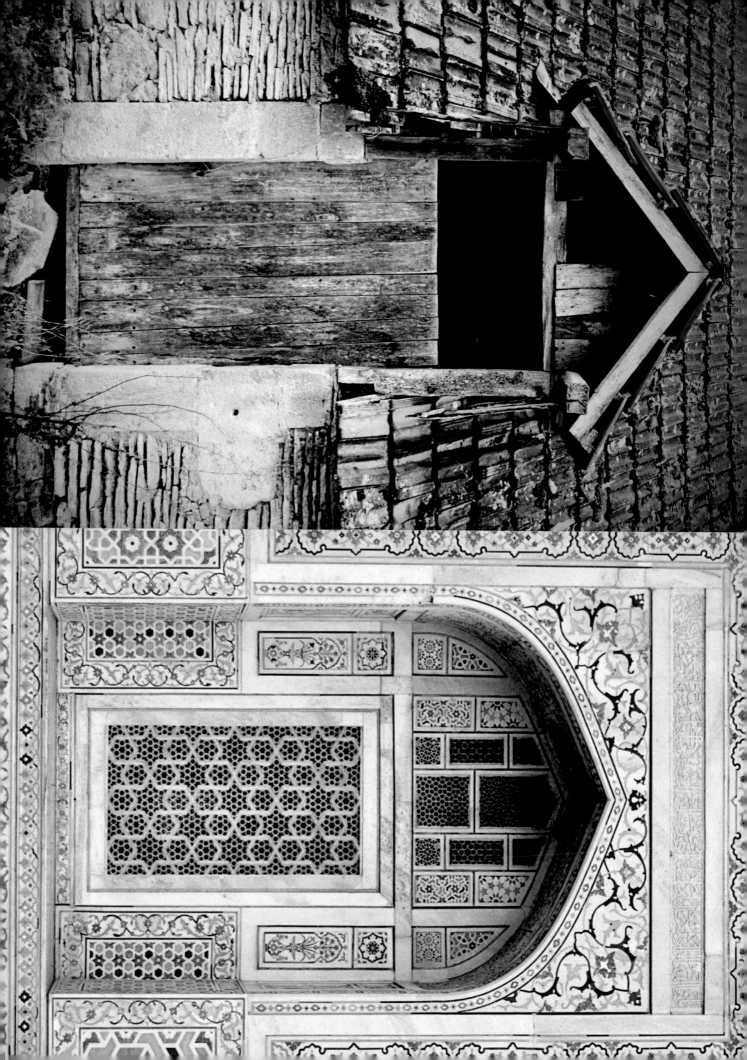

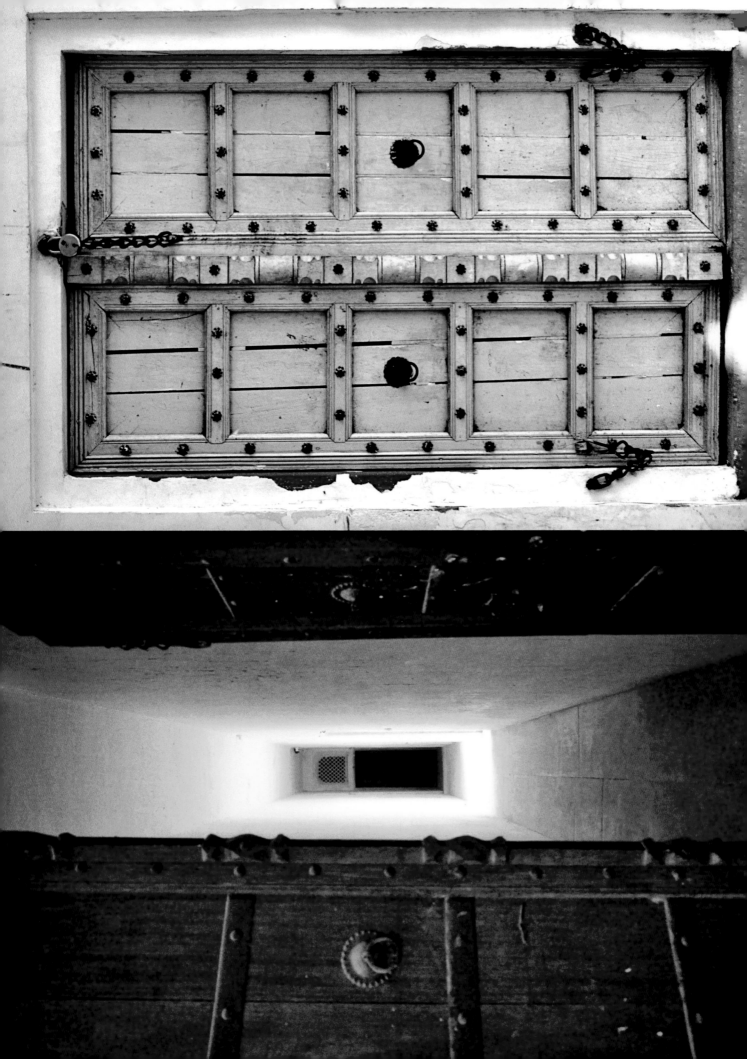

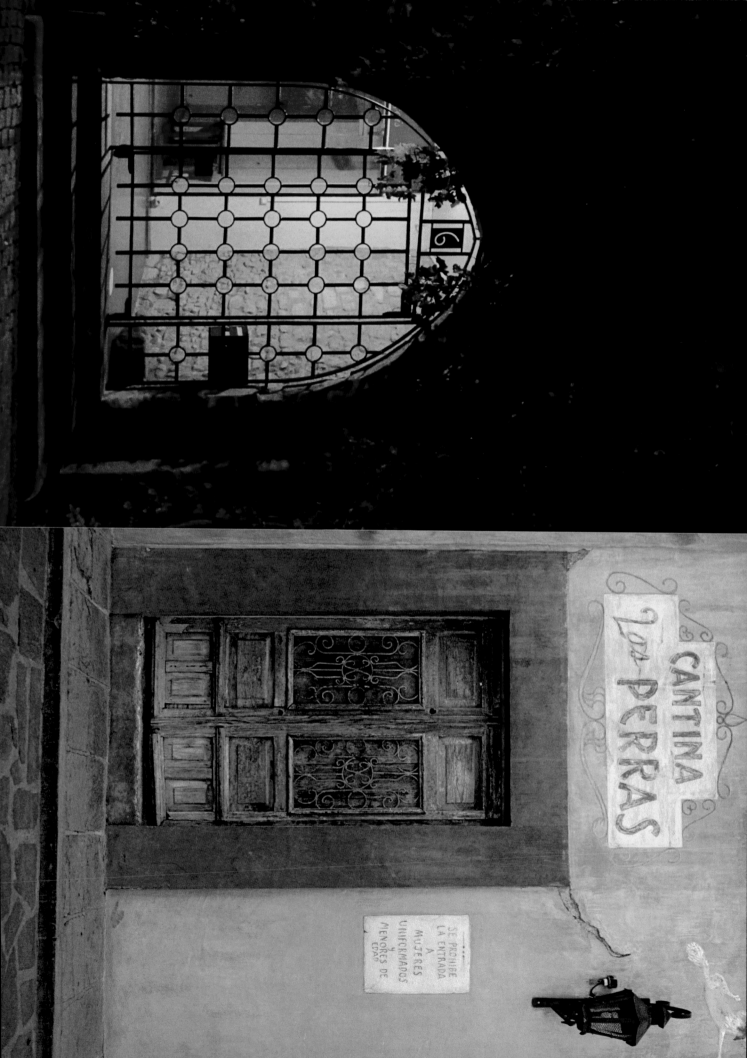

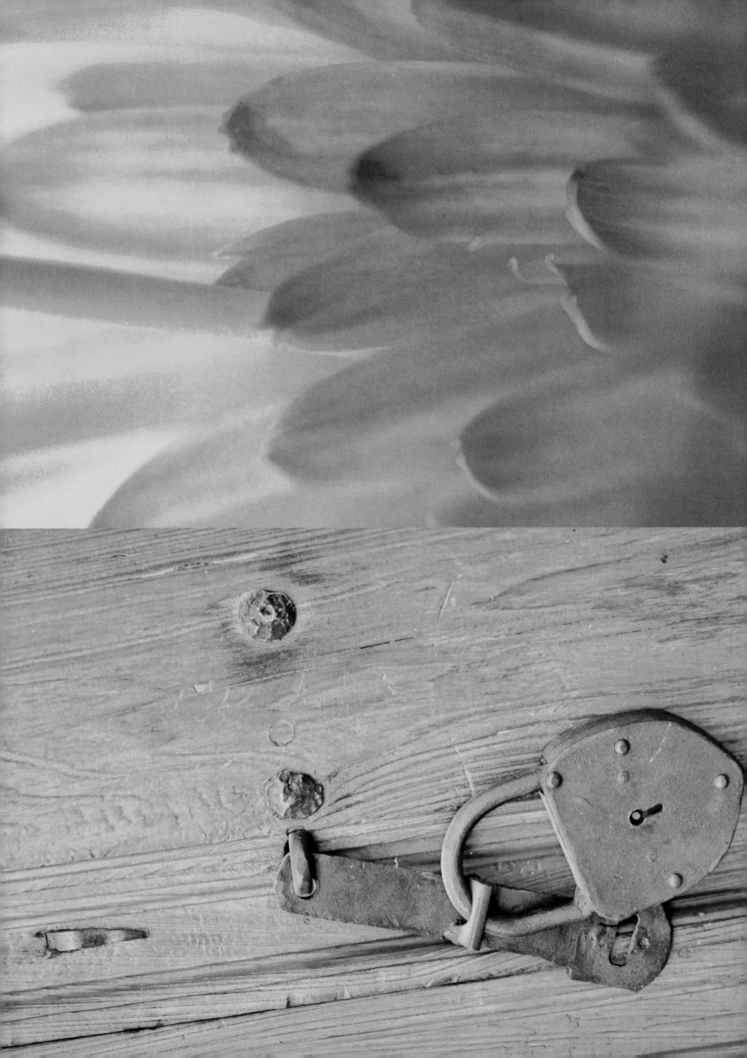

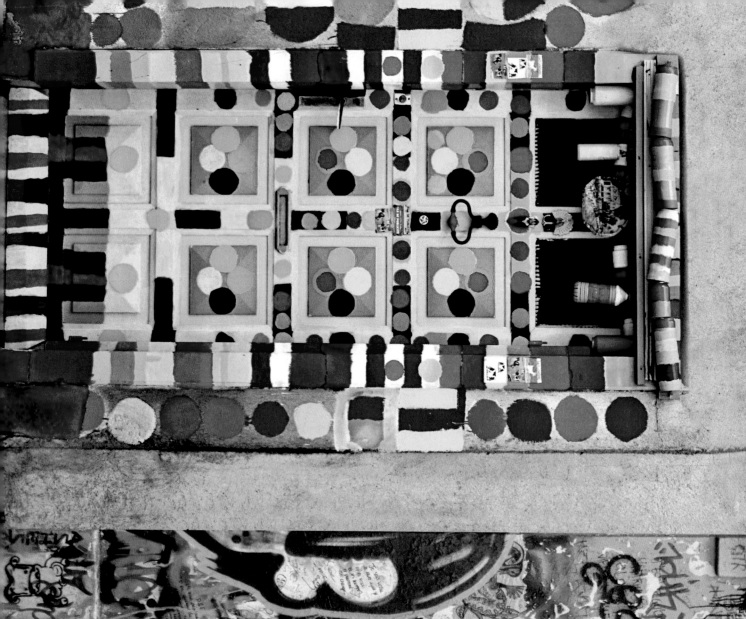
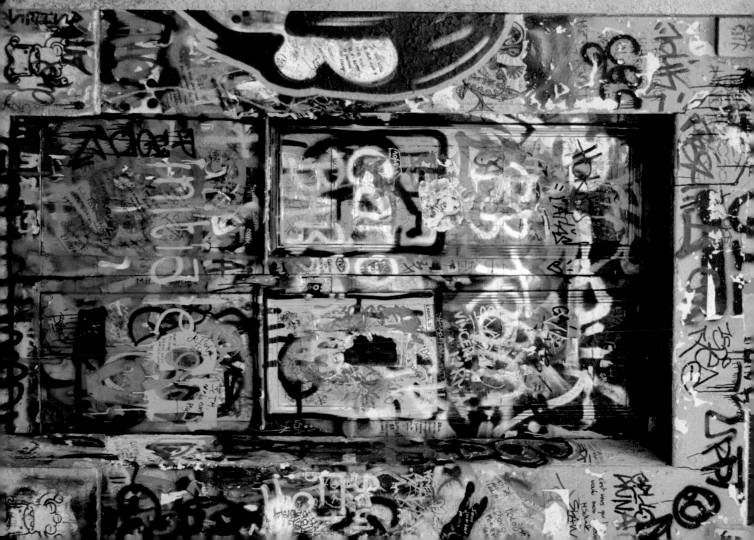

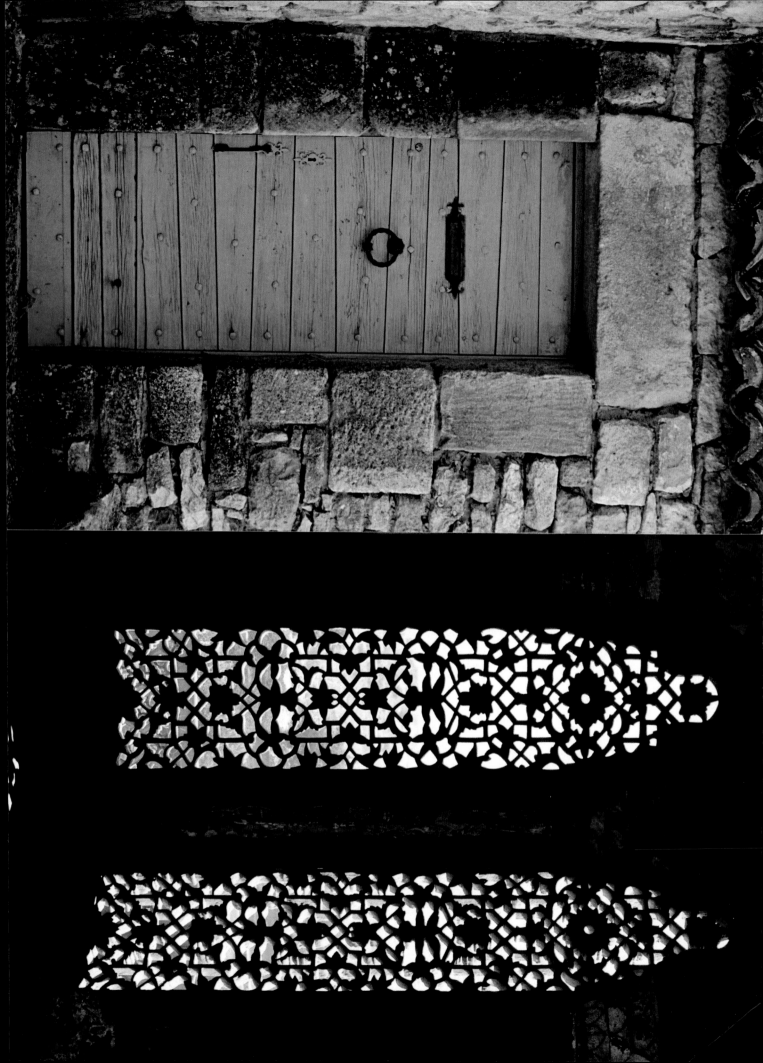

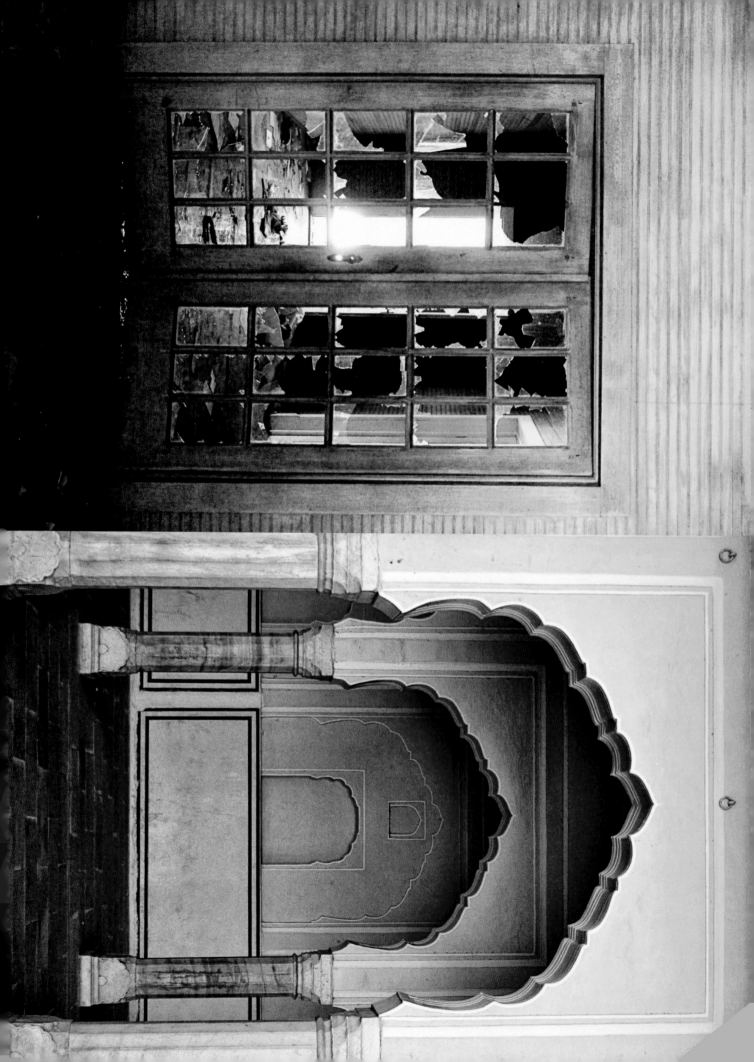

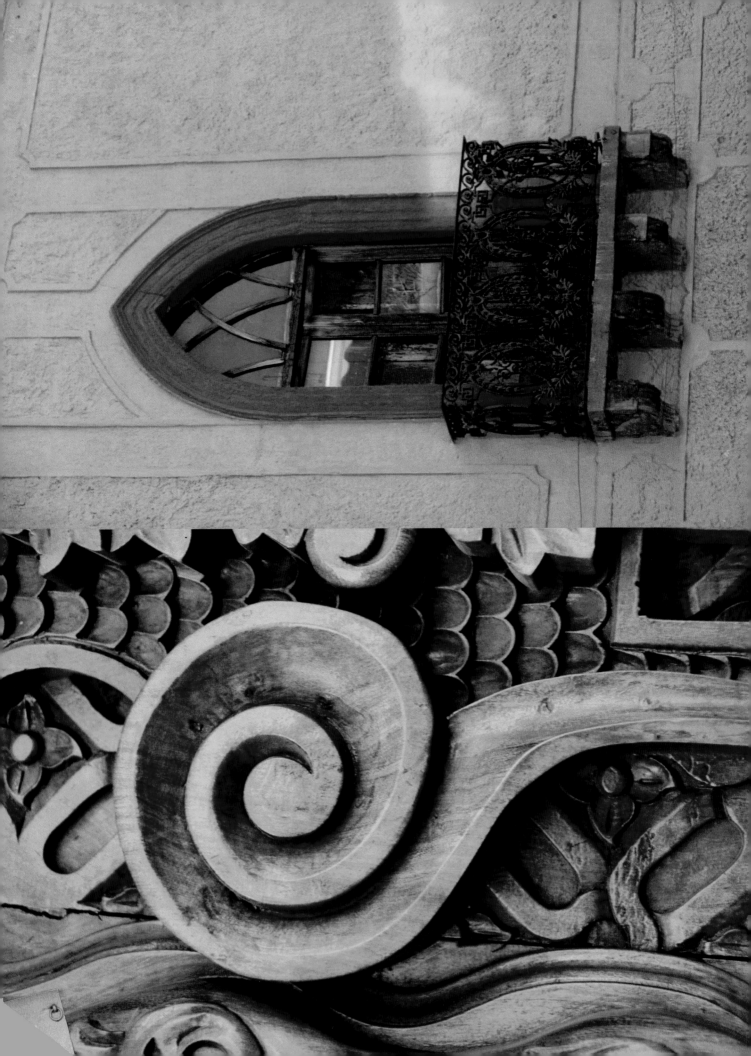

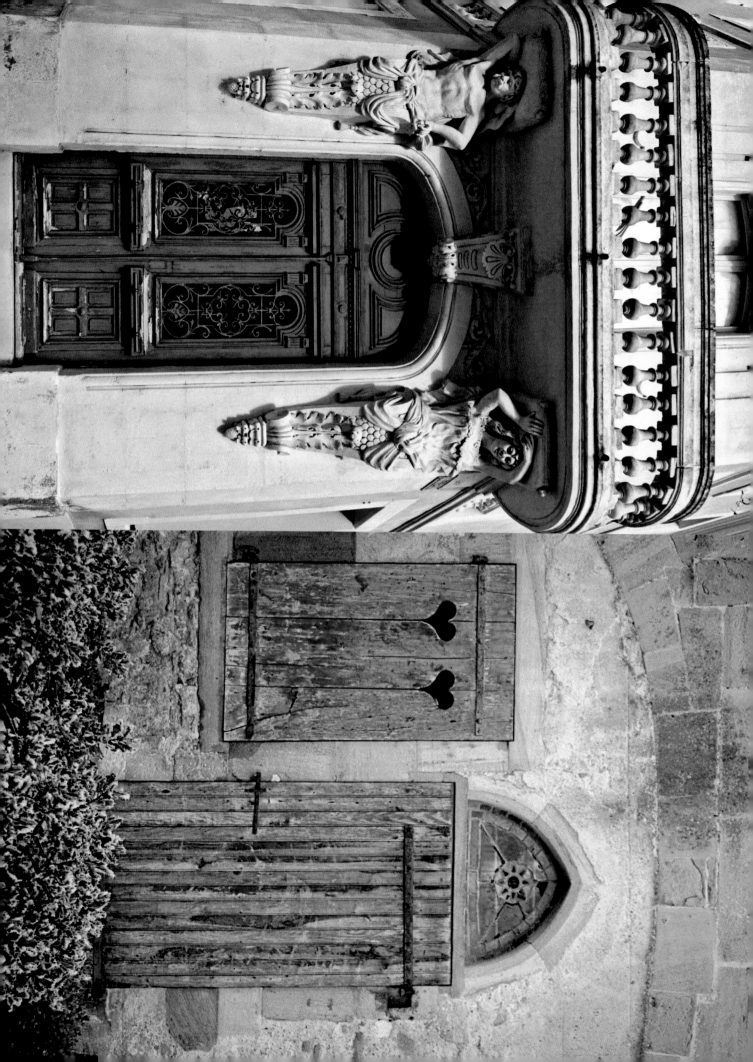

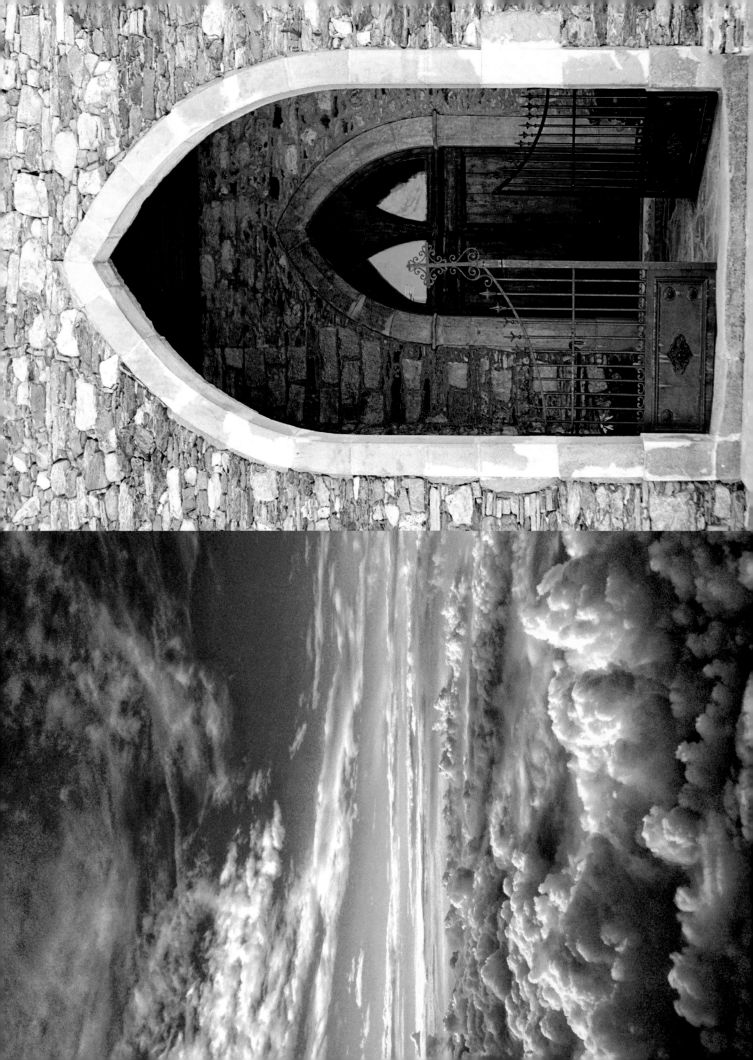

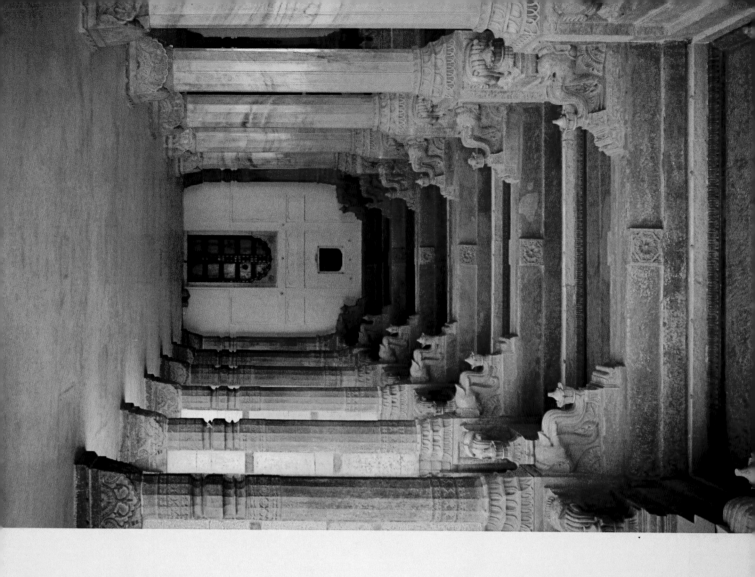
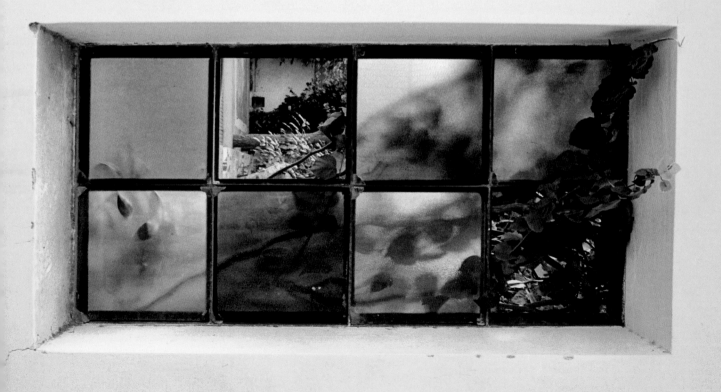

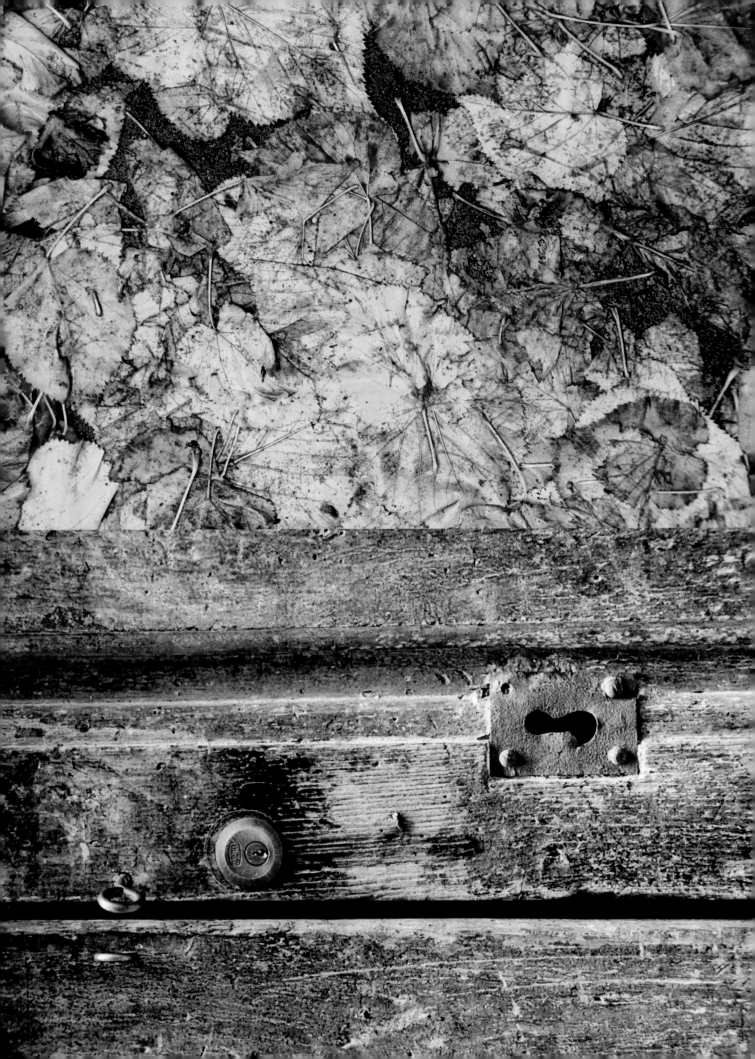

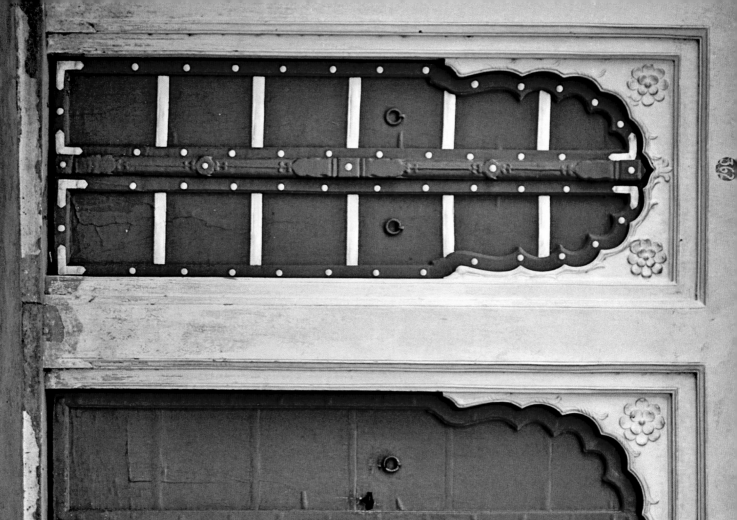

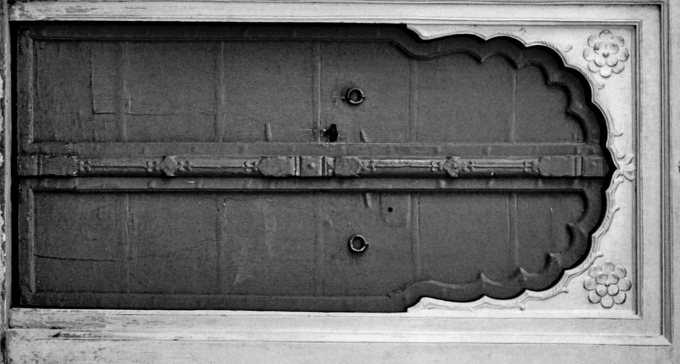

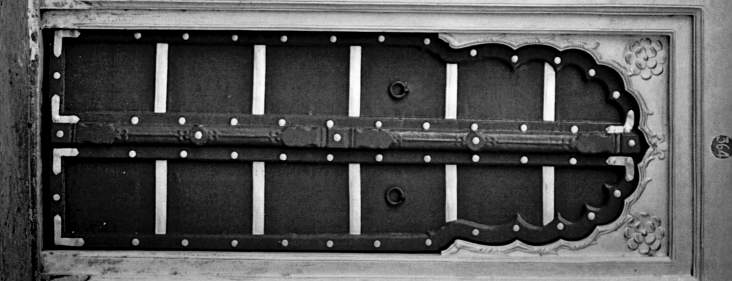

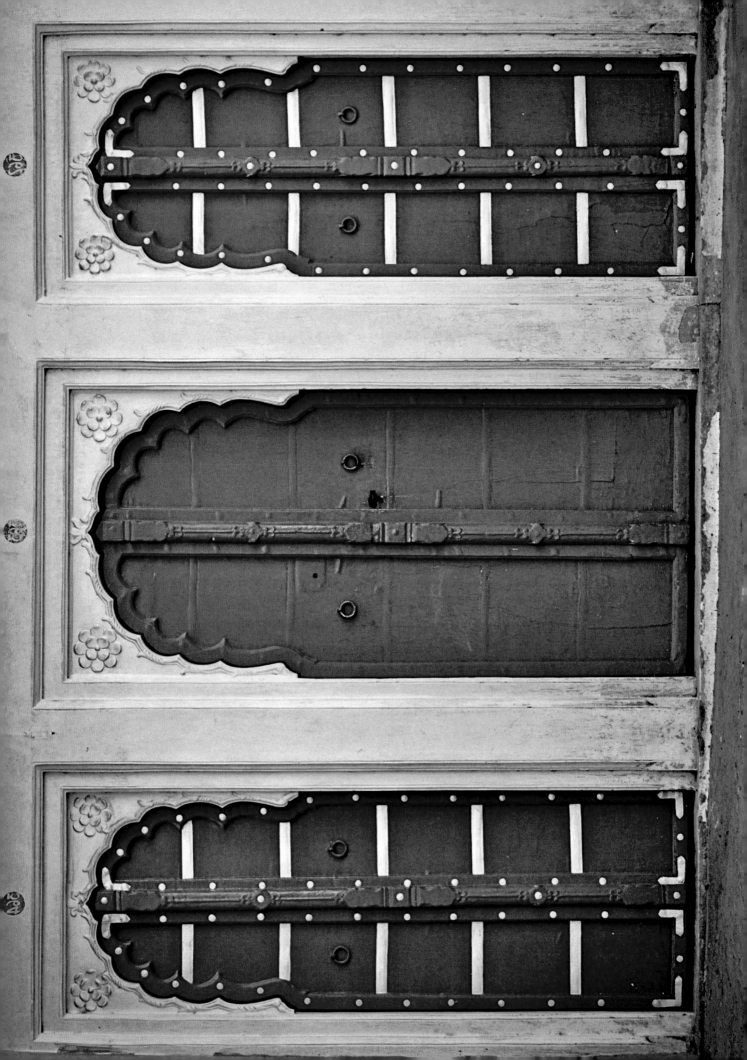

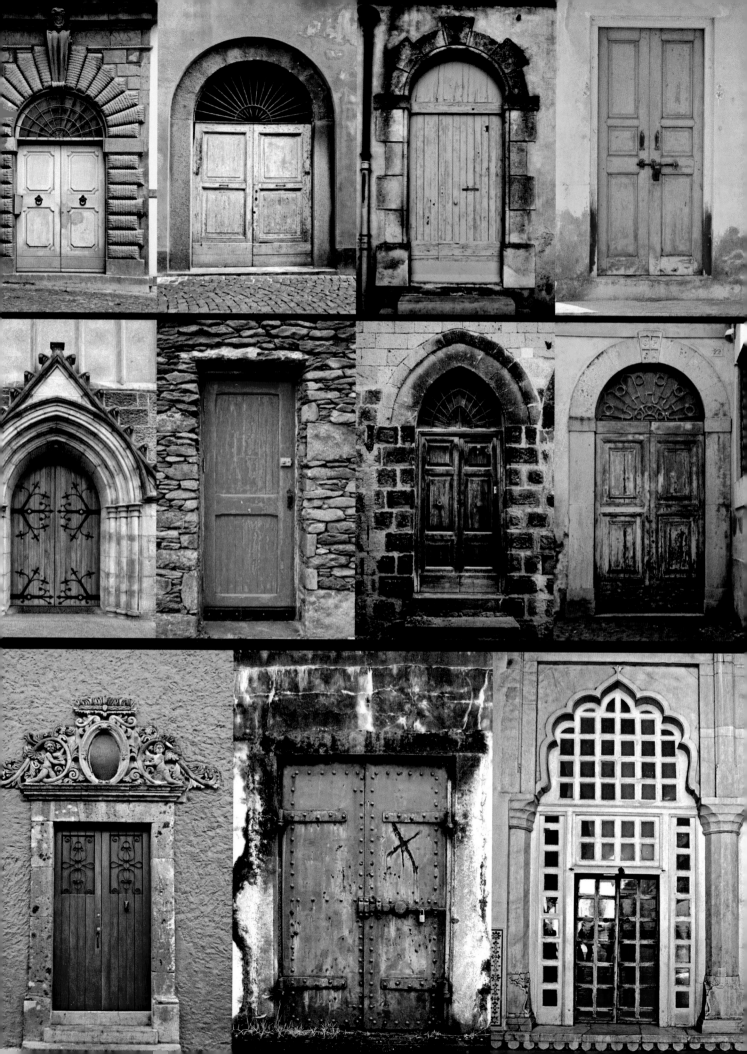

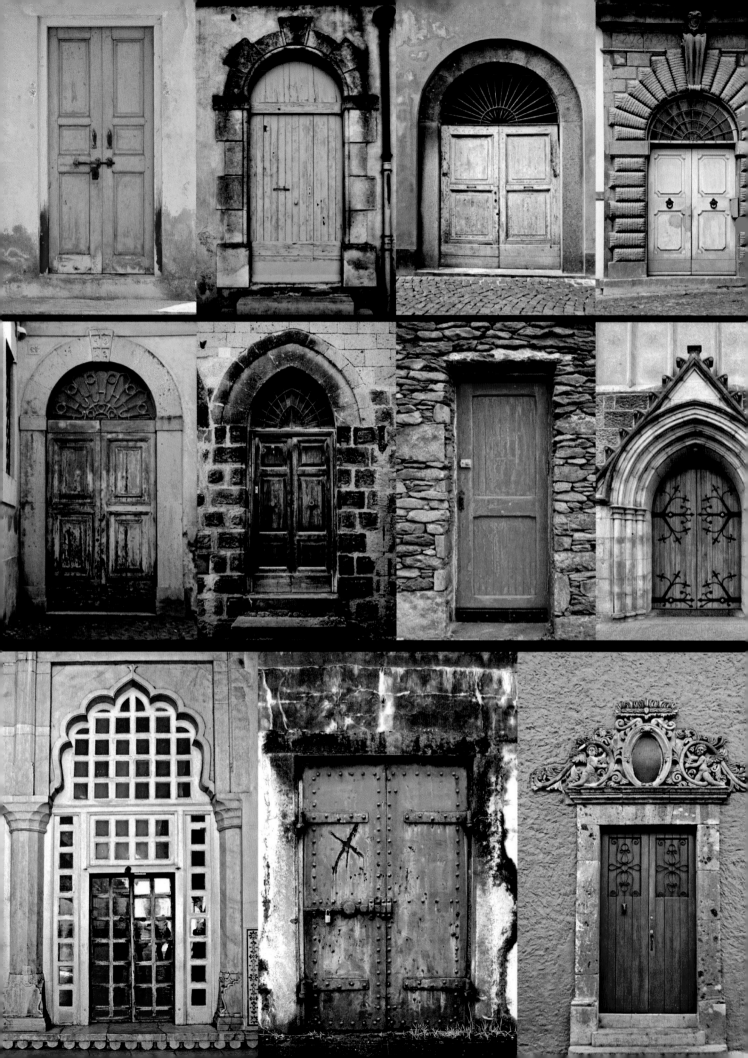

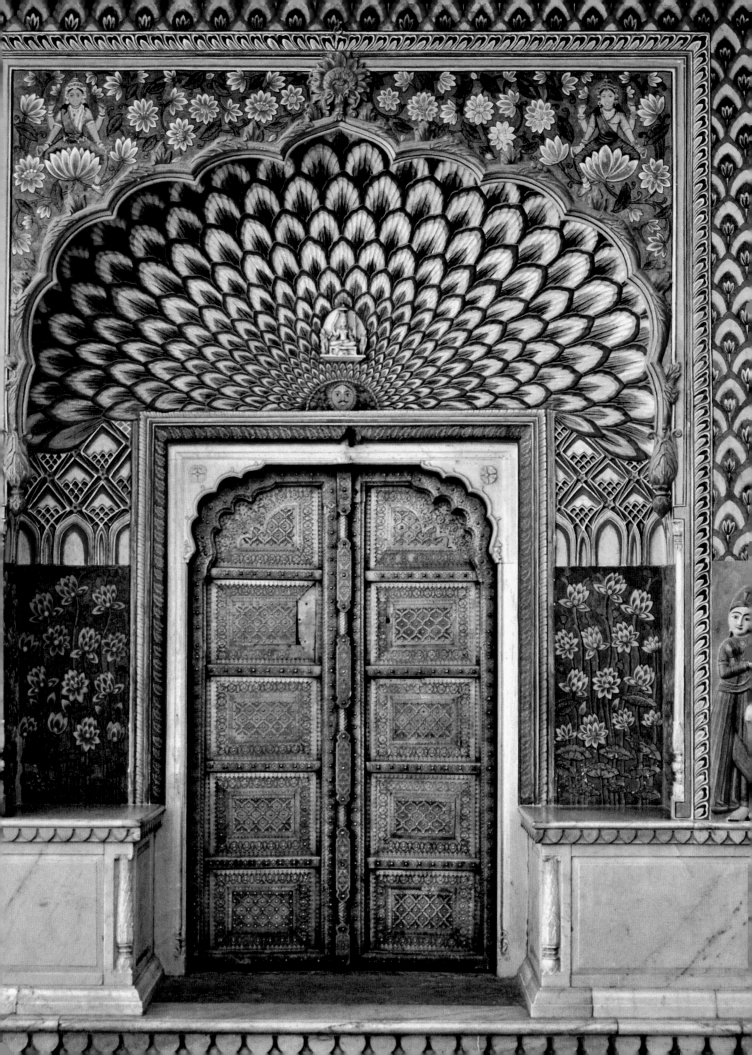

DOOR QUOTATIONS

Every doorway, every intersection, has a story.
Katherine Dunn

In oneself lies the whole world and if you know how to look and learn, the door is there and the key is in your hand. Nobody on earth can give you either the key or the door to open, except yourself.
J. Krishnamurti

When the doors of perception are cleansed, man will see things as they truly are, infinite.
William Blake

When one door of happiness closes, another opens; but often we look so long at the closed door that we do not see the one which has been opened for us.
Helen Keller

You must not for one instant give up the effort to build new lives for yourselves. Creativity means to push open the heavy, groaning doorway to life. This is not an easy struggle. Indeed, it may be the most difficult task in the world, for opening the door to your own life is, in the end, more difficult than opening the doors to the mysteries of the universe.
Daisaku Ikeda

To find one's way anywhere one has to find one's door, just like Alice, you see. You take too much of one thing and you get too big, then you take too much of another and you get too small. You've got to find your own doorway into things.
Paula Rego

If we knock on the door until it opens, not taking no for an answer, our lives will be transformed as we step up into a higher awareness.
James Redfield

No pessimist ever discovered the secret of the stars, or sailed to an unchartered land, or opened a new doorway for the human spirit.
Helen Keller

There is always one moment in childhood when the door opens and lets the future in.
Graham Greene

Why do you stay in prison when the door is so wide open? Move outside the tangle of fear-thinking.
Rumi

Happiness often sneaks in through a door you didn't know you left open.
John Barrymore

When a great moment knocks on the door of your life, it is often no louder than the beating of your heart, and it is very easy to miss it.
Boris Pasternak

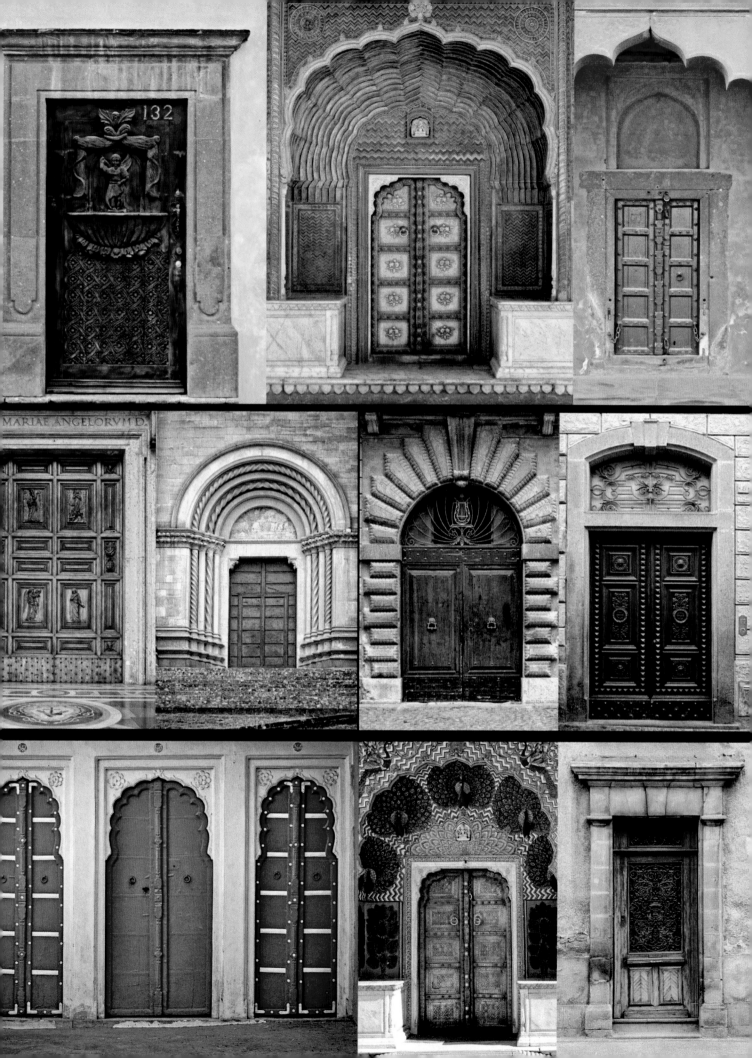

Wherever you are is the entry point.
Kabir

There are things known,
And there are things unknown,
And in between are the doors.
Jim Morrison

Thresholds hold a mystery; a mystery that lives in a neither/nor place. Thresholds are not only sacred places, but are also places of great fear, incubation and gestation. When we move into a threshold place, we leave Chronos, or linear time, and enter Kairos, or timelessness.
Constance S. Rodriquez in *Sacred Portals: Pathways to the Self*

He had the vague sense of standing on a threshold, the crossing of which would change everything.
Kate Morton in *The Forgotten Garden*

The teacher who is indeed wise does not bid you to enter the house of his wisdom but rather leads you to the threshold of your mind.
Kahlil Gibran

Every horizon, upon being reached, reveals another beckoning in the distance.
Always, I am on the threshold.
W. Eugene Smith

The doors we open and close each day decide the lives we live.
Flora Whittemore

When you follow your bliss ... doors will open where you would not have thought there would be doors; and where there wouldn't be a door for anyone else.
Joseph Campbell

The door to opportunity is always labeled 'push'.
Anon

The traveler has to knock at every alien door to come to his own, and he has to wonder through all the outer worlds to reach the innermost shrine at the end.
Rabindranath Tagore

A threshold is not a simple boundary; it is a frontier that divides two different territories, rhythms, and atmospheres.
John O'Donohue in *To Bless The Space Between Us*

It is wise in your own life to be able to recognize and acknowledge the key thresholds:
to take your time, to feel all the varieties of presence that accrue there, to listen inwards with complete attention until you hear the inner voice calling you forward. The time has come to cross.
John O'Donohue in *To Bless The Space Between Us*

What we really want to do is what we are really meant to do. When we do what we are meant to do, money comes to us, doors open for us, we feel useful, and the work we do feels like play to us.
Julia Cameron

Commitment unlocks the doors of imagination, allows vision, and gives us the "right stuff" to turn our dreams into reality.
James Womack

Our senses are indeed our doors and windows on this world, in a very real sense the key to the unlocking of meaning and the wellspring of creativity.
Jean Houston

There are things known and there are things unknown, and in between are the doors of perception.
Aldous Huxley

I feel very adventurous. There are so many doors to be opened, and I'm not afraid to look behind them.
Elizabeth Taylor

We keep moving forward, opening new doors, and doing new things, because we're curious and curiosity keeps leading us down new paths.
Walt Disney

Remember, the entrance door to the sanctuary is inside you.
Rumi

Open minds lead to open doors.
Unknown

As I walked out the door toward the gate that would lead to my freedom, I knew if I didn't leave my bitterness and hatred behind, I'd still be in prison.
Nelson Mandela

Fear knocked at the door. Faith answered. There was no one there.
Martin Luther King Jr.

Every exit is an entrance to somewhere else.
Tom Stoppard

Be an opener of doors for such as come after thee.
Ralph Waldo Emerson

About Catherine

Catherine Anderson is author of *The Creative Photographer*, a book that combines inspiration, instruction and hands-on exercises to guide you in taking your photography to a more creative level. In addition the book gives you many ways to share your images through the use of mixed-media processes.

Catherine offers creative photography workshops and retreats in the US, Italy, France and South Africa. Her focus is on using photography as a meditative practice which encouages us to slow down and see the world in a new way. She also shares her love of mixed media projects using images and paints in online workshops.

Catherine's books *The Creative Photographer*, *Journaling the Labyrinth Path* and *Collage Imagery* are available through www.amazon.com.

For more information, visit Catherine's website www.creativepilgrimage.com

Made in the USA
Las Vegas, NV
14 March 2024

87174811R00043